inspirational
Quotes
illustrated

ART and
WORDS to
MOTIVATE

LESLEY RILEY

NORTH LIGHT BOOKS
Cincinnati, Ohio
CreateMixedMedia.com

contents

TO DOWNLOAD DIGITAL WALLPAPER OF SELECT IMAGES FROM *INSPIRATIONAL QUOTES ILLUSTRATED*, VISIT CREATEMIXEDMEDIA.COM/INSPIRATIONAL-QUOTES-ILLUSTRATED.

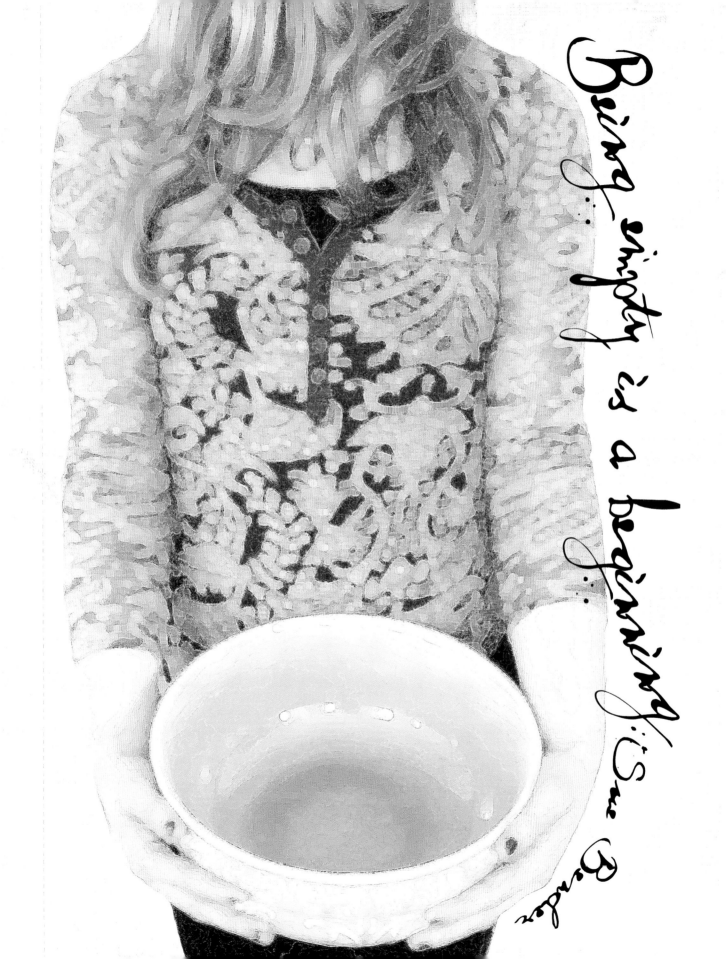

Being empty is a beginning...
—Sue Bender

THE STORY
behind this book

My first introduction to quotes was my father's well-worn, blue hardback copy of *Bartlett's Familiar Quotations.* I remember it being quite heavy for my ten-year-old hands—a large book with tiny print filling just about every inch on every page. This book was full of amazing insight and wisdom. I understood the magic it held even at that early age.

Quotes became a visual obsession a few years later when the Abbey Press catalog arrived in our mailbox full of Sister Corita Kent's brightly colored 1960s-era illustrated quotes. It was the first place I read the words that set me on my path to becoming an artist:

"Whatever you do, or dream you can, begin it. Boldness has genius and power and magic in it." —Johann Wolfgang von Goethe

I have been collecting quotes for over fifty years. Thankfully it's much easier now with word processors, Internet quote sites and search engines. But I still love to pull my very 1960s colored journal off the shelf, smile at my teenage penmanship and read over the words that inspired and influenced me back then.

Today, finding a quote takes nothing more than a visit to Google to type in the few words of a specific quote I am looking for, or entering keywords for a new one. That is, if it's not already in my vast collection. I have a two-column, 126-page Microsoft Word document that right now contains 41,657 words of wisdom. By the time you read this, I know there will be more. I add to it daily.

You see, I'm fascinated by how much I glean and am inspired by the bite-sized thoughts of famous and not-so or not-even famous people that have been preserved for posterity. I call it "quotespiration."

Back in 1989, I tucked Goethe's quote into that whisper of a space between the frame and the mirror so I would see it every day. "Whatever you do, or dream you can, begin it." Begin it, begin it . . . It took me several years to work up the courage to begin it. Ten to be exact. And I can tell you now, fifteen years later, that it's so true, so powerfully true. Boldness does have "genius and power and magic in it." This book you hold in your hands is evidence.

As a quote collector, one of the things that fascinates me most is how often you will hear the same wisdom or knowledge shared again and again by so many different people over time—even centuries. They endure, perhaps in part to being short and concise—most quotes are less than three sentences. Marcus Tullius Cicero (106 BC–43 BC), who preserved many ancient quotes with his writings, said, "Brevity is a great charm of eloquence."

In today's fast-paced world of short attention spans and sound-bite journalism, they still deliver a punch of wisdom or inspiration on the go. Just peek inside Oprah's *O* magazine for her monthly quote cards or the multitude of Pinterest boards devoted to quotes. Quotespiration spans generations, societies and cultures. The impact and influence are ageless.

Quotes are powerful. They are preserved moments of wisdom, insight and truth. Quotes inspire, guide and remind. They speak of what we know but haven't been paying attention to and make us want to pay attention.

In his book *Quotology*, Willis Goth Regier says, "Oh to say something so fine, so memorable, that it carries across time, oceans, and languages . . . as if a few sentences, or one alone, could touch hearts, grasp truth, and endure."

The book you now hold in your hands is the culmination of a dream. It is a combination of the two things that I carry in my heart and soul as guiding lights: quotes and art. It is my attempt at the ultimate in inspiration—words and works of art that will move you to smile, to feel happy and think positive. Most of all, I hope to inspire you to take action on your dreams.

This book is a result of the friendship and community I have found by taking action on my dreams and following my passion. It would not be anywhere near as expressive and rich without the many artists who responded to my call for art. My seed of an idea became a rich community garden of delight thanks to their contributions. This book would not exist without their time and talent. I want to thank you, too, for sharing this experience with me.

This edition of *Inspirational Quotes Illustrated* is the magic that Goethe said would appear when you take action. My original self-published edition, entitled *Quotes Illustrated*, became a number one best-seller on Amazon in its one short month of availability. Within a week of its publication, Tonia Jenny of North Light Books asked me if North Light could acquire the book. It has always been my goal to reach and inspire more people, and a mass market publisher can make that happen. So I said a holy "YES!"

"Our task is to say a holy yes to the real things of our life as they exist—the real truth of who we are."—Natalie Goldberg

"To do something, however small, to make others happier and better, is the highest ambition, the most elevating hope, which can inspire a human being."
—John Lubbock

LESLEY RILEY

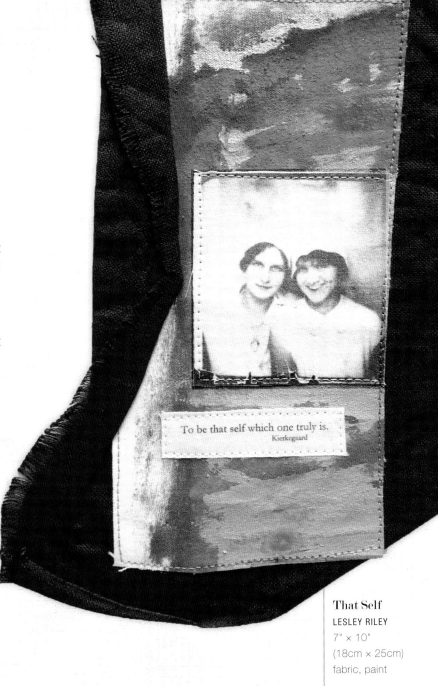

That Self
LESLEY RILEY
7" × 10"
(18cm × 25cm)
fabric, paint

> To be that self which one *truly* is.

SØREN KIERKEGAARD

" *Time* is not a line, but a series of now points.

{ TAISEN DESHIMARU }

Waiting With My Father for the Martins | MEG GREENE
6" × 10" (15cm × 25cm)
digital collage: photograph

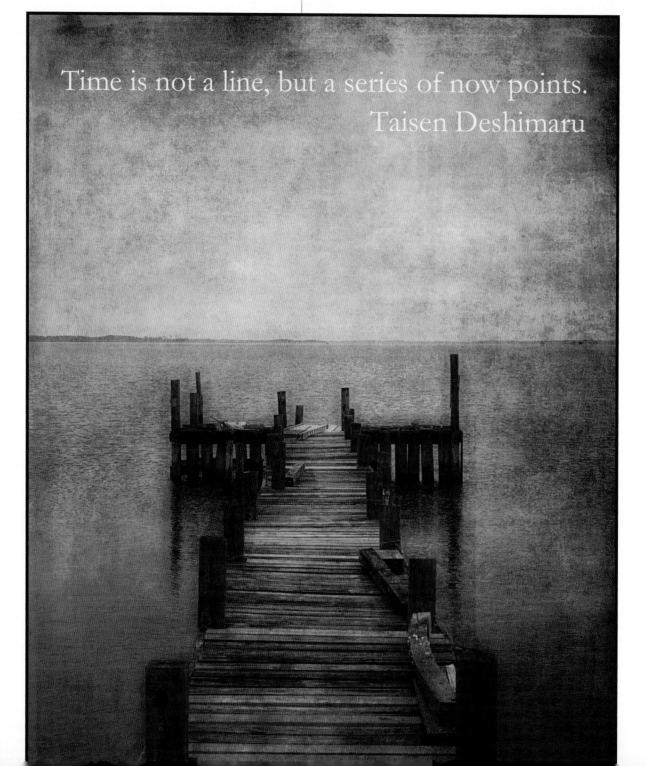

Time is not a line, but a series of now points.
Taisen Deshimaru

> **❝** I love even the *smallest thing* of all and I paint it on a golden background and make it visible in order that it moves someone even if I don't know whom.

{RAINER MARIA RILKE}

The Smallest Thing | SERENA BARTON
6" × 6" (15cm × 15cm)
painting: oil, cold wax

> The woman's *place of power within* each of us is neither white nor surface, it is dark, it is ancient, it is deep.

AUDRE LORDE

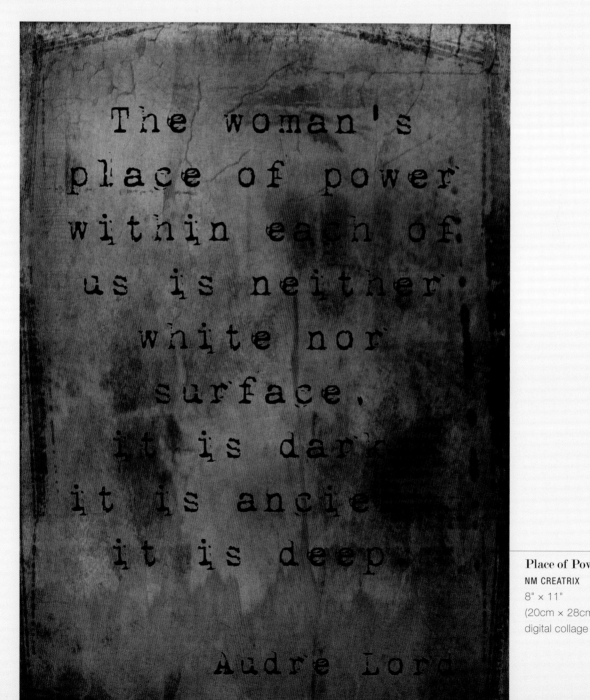

Place of Power
NM CREATRIX
8" × 11"
(20cm × 28cm)
digital collage

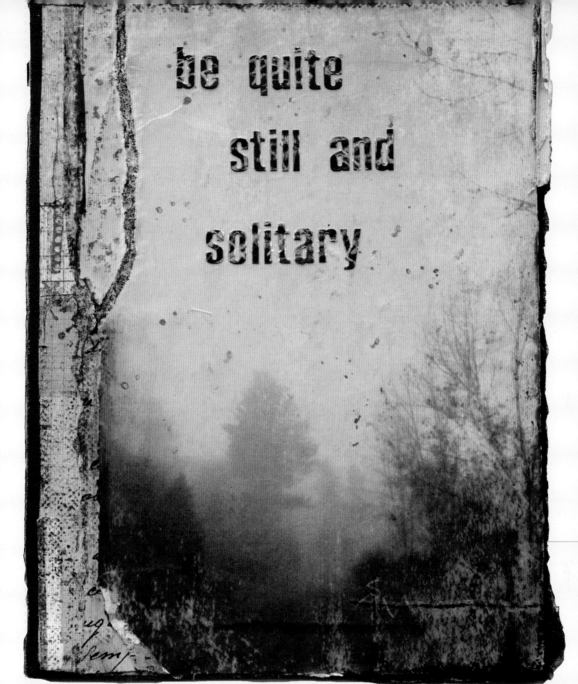

Quite Still
SETH APTER
5½" × 7"
(14cm × 18cm)
book cover
collage:
photograph paper,
ink, wax pastel,
crayon, lettering

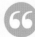

Be quite still and solitary. The world will freely offer itself to you unmasked. It has no choice. *It will roll in ecstasy at your feet.*

FRANZ KAFKA

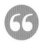

You've got to *jump off cliffs* all the time
and build your wings on the way down.

RAY BRADBURY

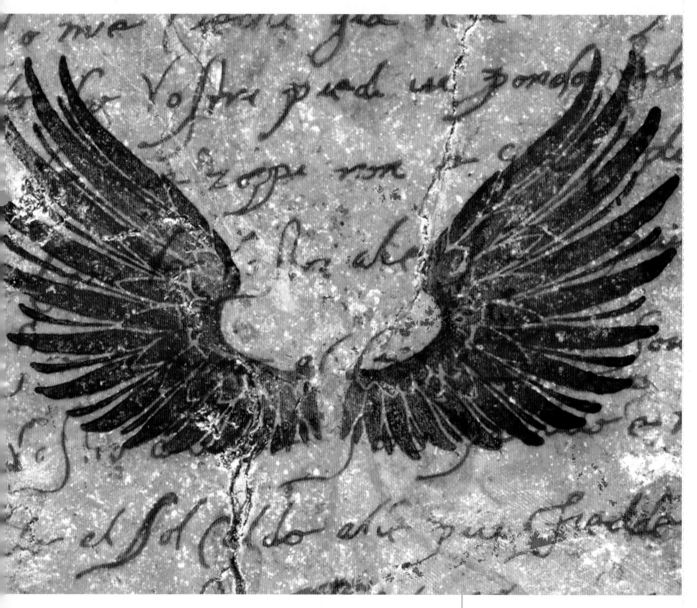

Soaring | STACEY MERRILL
10" × 8" (25cm × 20cm)
mixed media: drawing, painting,
stamps, digital manipulation

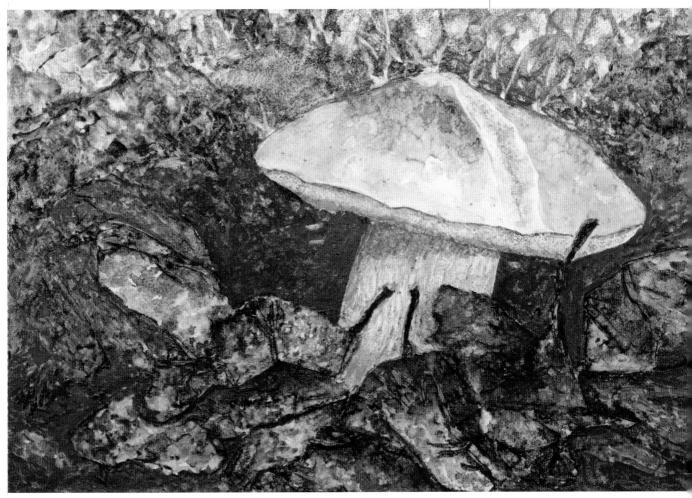

PHOTO BY MURRAY LITTLE

Action in the face of uncertainty is *essential to creation.*

JONATHAN FIELDS

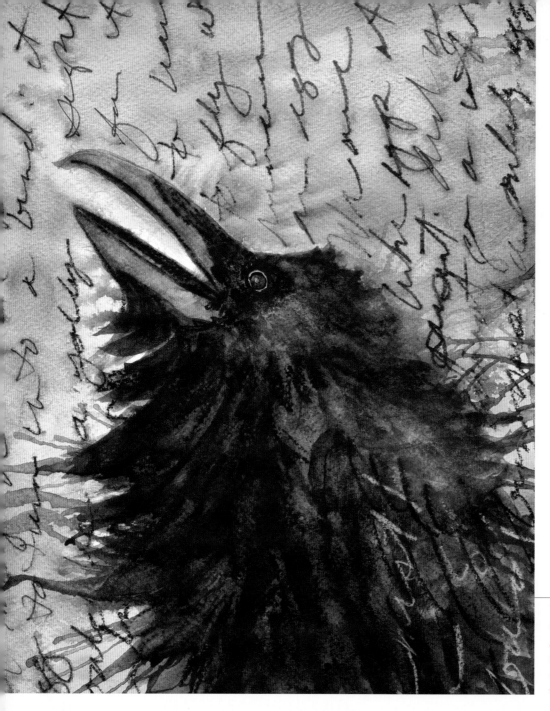

Untitled
GINA ROSSI
ARMFIELD
9" × 12"
(23cm × 30cm)
watercolor

" It may be hard for an egg to turn into a bird: It would be a jolly sight harder for it to *learn to fly* while remaining an egg. We are like eggs at present. And you cannot go on indefinitely being just an ordinary, decent egg. We must be hatched or go bad.

{ C.S. LEWIS }

> ❝ I put on *my dream-cap* one day and stepped into Wonderland.
>
> {HOWARD PYLE}

Inspiration Arriving
CATHERINE ANDERSON
8" × 10" (20cm × 25cm)
digital photo collage: vintage papers, found images

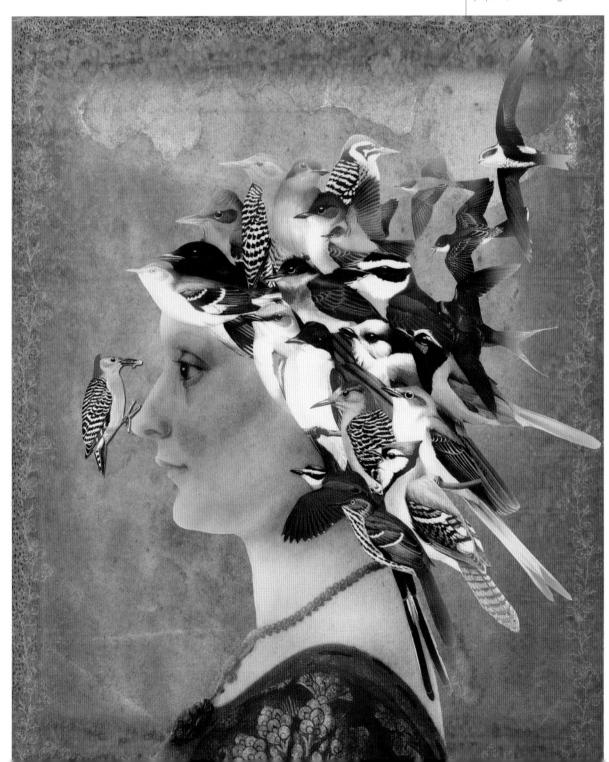

> **"** **The more I want to** *get something done,*
> the less I call it work.

{ RICHARD BACH }

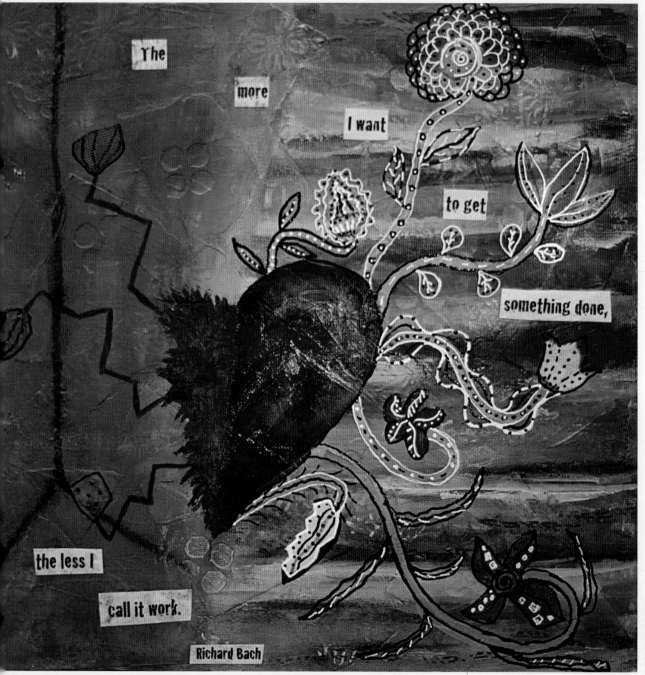

The image contains the following text fragments within it: "The", "more", "I want", "to get", "something done,", "the less I", "call it work.", "Richard Bach"

Call It Joy | LINDA C. BANNAN
12" × 12" (30cm × 30cm)
mixed-media collage: acrylic paint,
textured paper, dimensional pens

PHOTO BY MIKE BANNAN

14

Organic Red— Steps of Vision | ADEOLA DAVIES-AIYELOJA
14" × 14" (36cm × 36cm)
mixed-media painting on board with acrylic skins

> ❝ I found I could *say things with color* and shapes that I couldn't say any other way— things I had no words for.

{ GEORGIA O'KEEFFE }

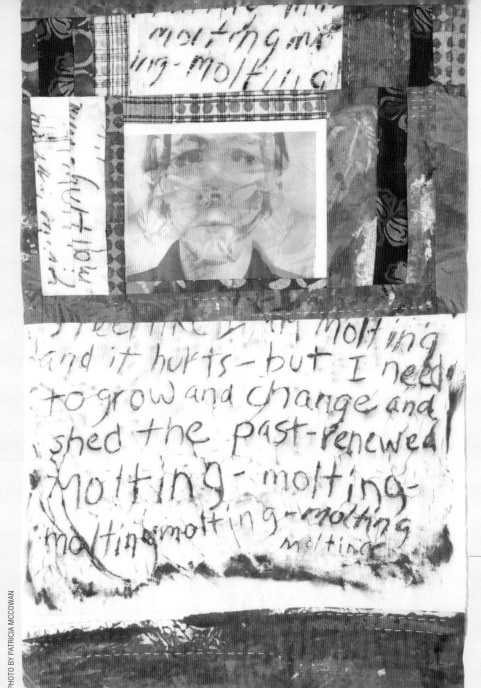

Molting
ANN-MARIE LABOLLITA
12" × 22" (30cm × 56cm)
mixed media: dye, paint,
screen print, digital
photograph, wax and flour
paste resist, machine piece
and hand quilting, recycled
cotton clothing, rayon

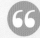

The *artwork labors* to create
itself: One must only not interfere.

JOYCE CAROL OATES

> **Look not too far afield . . . *Answers lie within.* What lies behind us and what lies before us are tiny matters compared to what lies within us.**
>
> — HENRY STANLEY HASKINS

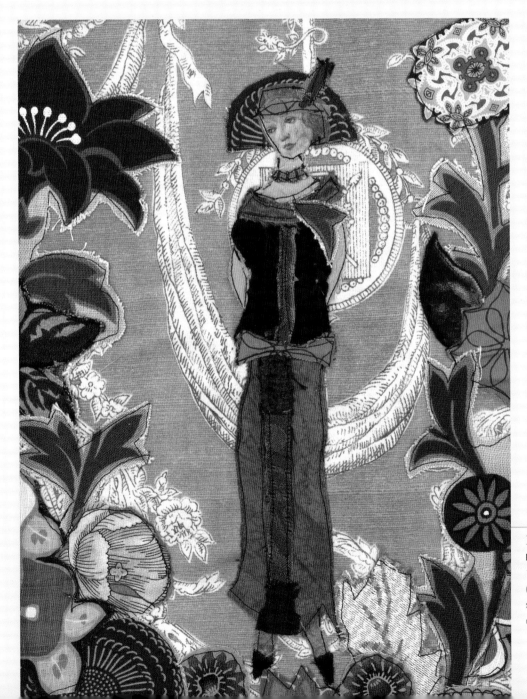

My Inner Garden
DAYLE DOROSHOW
11" × 14"
(28cm × 36cm)
stitched fabric
collage

You are what you are when *nobody is looking.*

{ABIGAIL VAN BUREN}

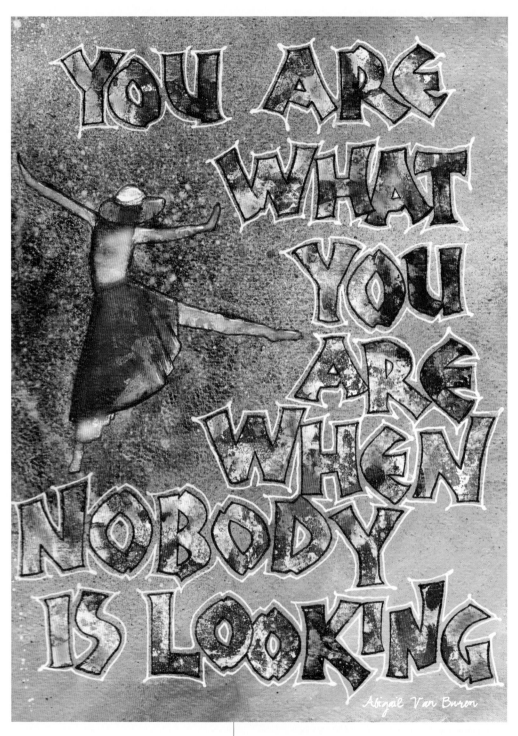

You Are What You Are When Nobody Is Looking
CHERYL BAKKE MARTIN
9" × 12" (23cm × 30cm)
mixed-media painting

We Are So
Many Selves
MARCIA BECKETT
8½" × 11"
(22cm × 28cm)
painting:
watercolor, acrylic
paint, markers,
scratching

" *We are so many selves* …the person we were last year, wanted to be yesterday, tried to become in one job or in one winter, in one love affair or even in one house where even now, we can close our eyes and smell the rooms.

{ GLORIA STEINEM }

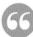

Perfection is achieved, not when there is nothing more to add, but *when there is nothing left* to take away.

ANTOINE DE SAINT-EXUPÉRY

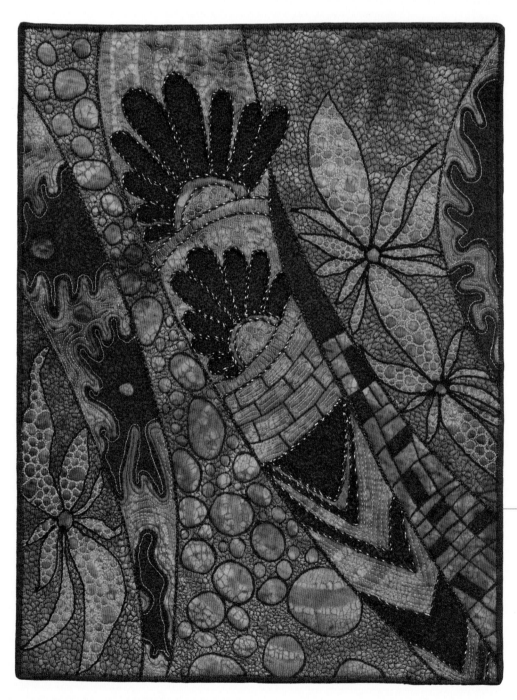

Autumn Paths
JOYCE L. CARRIER
10" × 12½"
(25cm × 32cm)
quilt: fabric,
cutaway, hand-
dyed silks, rayon,
thread, cording,
free motion
stitching, bobbin
work

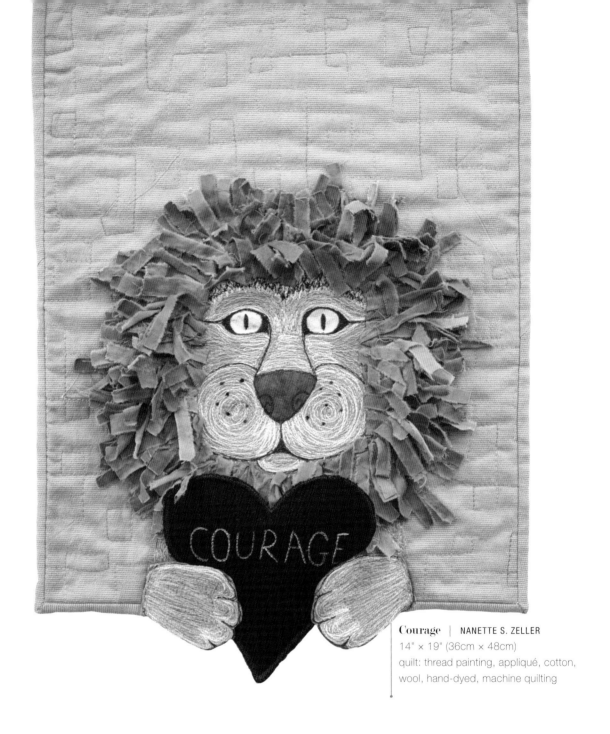

Courage | NANETTE S. ZELLER
14" × 19" (36cm × 48cm)
quilt: thread painting, appliqué, cotton,
wool, hand-dyed, machine quilting

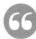

It takes a lot of *courage* to
show your dreams to someone else.

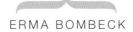

ERMA BOMBECK

Wider Possibilities | DEBORAH BOSCHERT
10½" × 12" (27cm × 30cm)
fabric collage: commercial and original fabrics,
paint, thread, embroidery floss, surface design,
machine quilting, hand embroidery

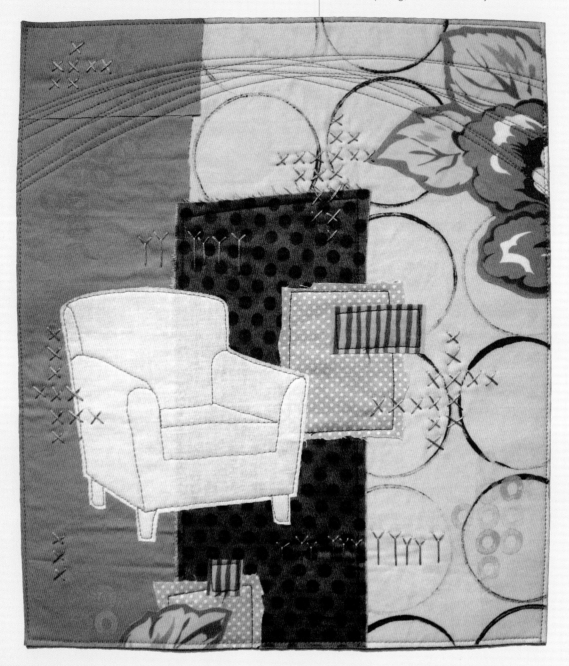

66 Never, never rest contented with any circle of ideas, but always be certain that a wider one is *still possible.*

{ PEARL BAILEY }

66 So you see, *imagination needs moodling—* long, inefficient, happy idling, dawdling and puttering.

{ BRENDA UELAND }

Mysteries of the Imagination | DARLENE CAMPBELL
36" × 24" (91cm × 61cm)
painting: fluid acrylics, molding paste, heavy gel
medium, fiber paste, mark-making tools

> Art attracts us only by *what it reveals* of our most secret self.

{ JEAN-LUC GODARD }

> **"** We are not human beings having a spiritual experience. *We are spiritual beings* having a human experience.

{ PIERRE TEILHARD DE CHARDIN }

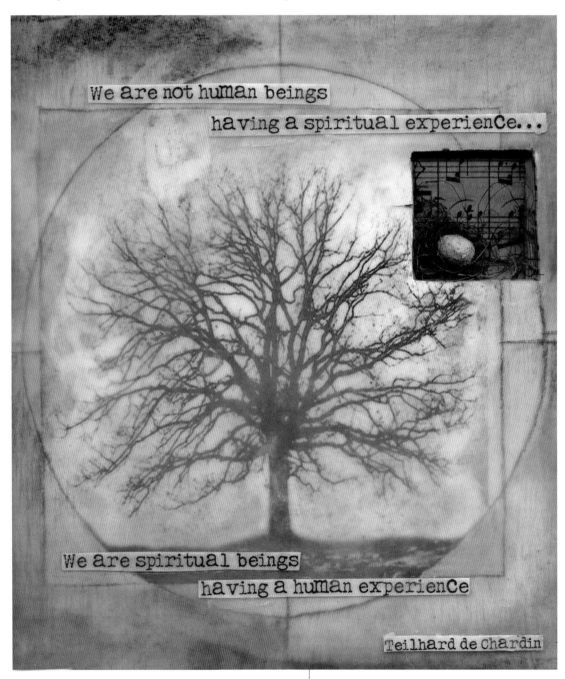

Spiritual Beings | PATTI MONROE-MOHRENWEISER
8½" × 10" (22cm × 25cm)
encaustic painting: image transfer, graphite, drawing

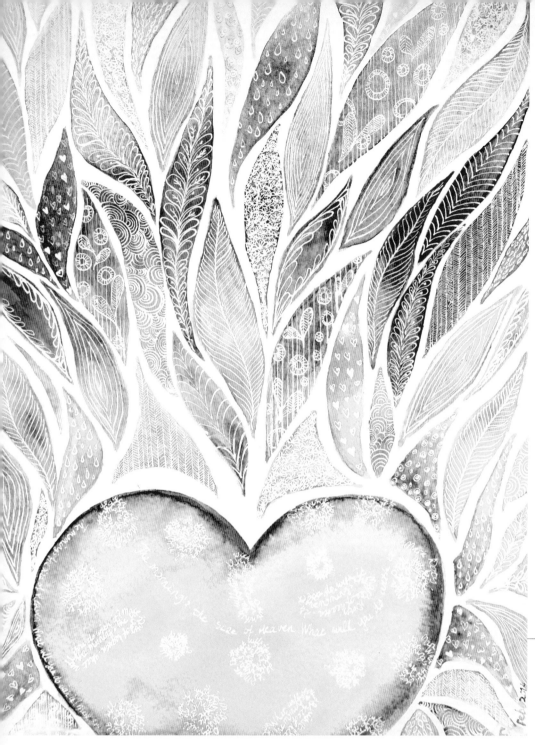

Sunrise
FAJARI BERTELS-THENU
9½" × 12½"
(24cm × 32cm)
watercolor: painting,
dip pen drawing

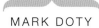

The morning's *the size of heaven.*
What will you do with it?

MARK DOTY

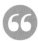

There is no doing it right; there's just being with what is *as wholeheartedly as the moment allows.*

STEPHEN LEVINE

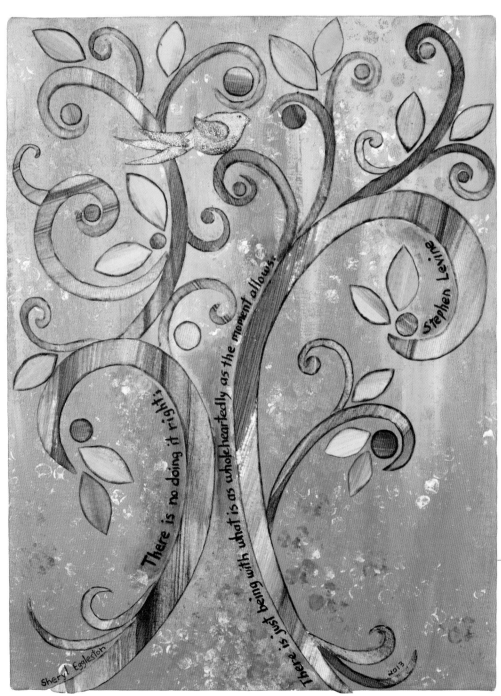

Pink Tree in Paradise
SHERYL EGGLESTON
16" × 20"
(41cm × 51cm)
watercolor: paper
collaged on
painted canvas

Art to me was a state; it didn't need to be an accomplishment.

{ MARGARET ANDERSON }

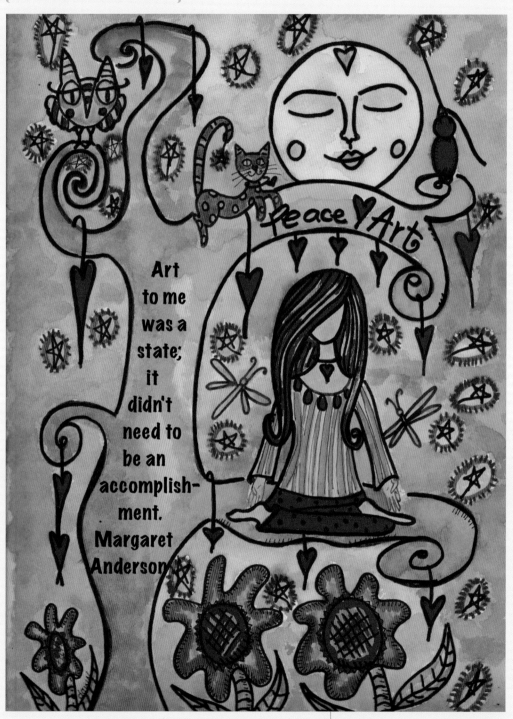

Meditating Girl | DAWN COLLINS
9" × 12" (23cm × 30cm)
layered mixed-media painting

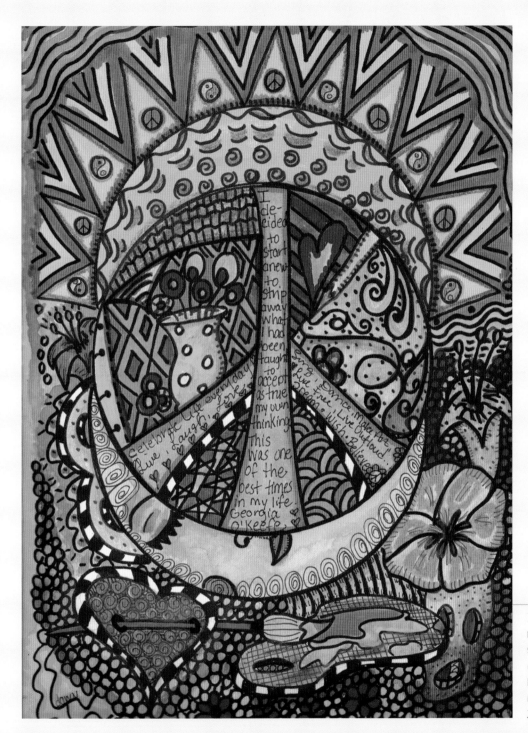

Peace Art
DAWN COLLINS
9" × 12"
(23cm × 30cm)
layered mixed-
media painting:
Zentangle®

❝ I desired to *start anew*, to strip away what I had been taught, to accept as true my own thinking. This was one of the best times in my life.

{ GEORGIA O'KEEFFE }

" *Bury doubt* under wonder.

{ RUTH RADLAUER }

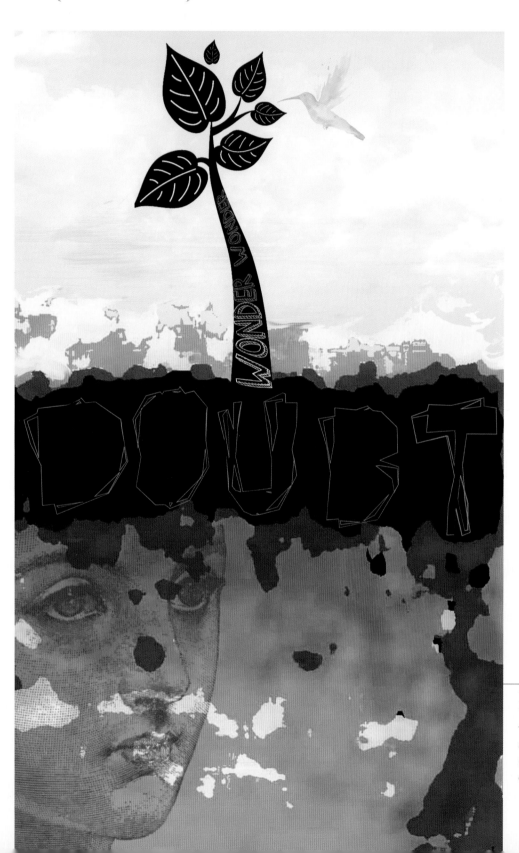

**Bury Doubt
Under Wonder**
TAMARA TOLKIN
8½" × 14"
(22cm × 36cm)
digital collage

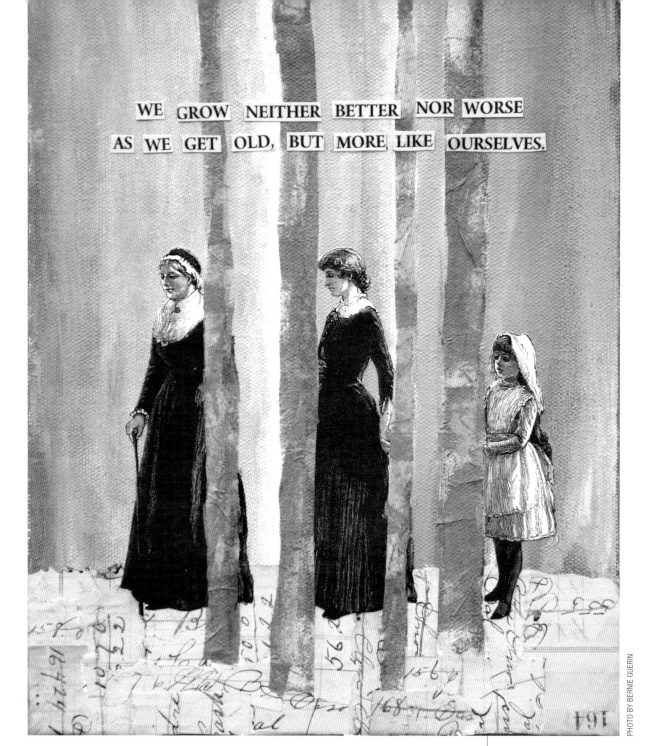

Untitled | PAULA GUERIN
8" × 10" (20cm × 25cm)
collage and paint on
wrapped canvas

" We grow neither better nor worse as we grow old, but *more like ourselves.*

{ MAY LAMBERTON BECKER }

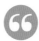

Inspiration exists, but it has to find you working.

PABLO PICASSO

At Work in the Studio | AMY DUNCAN
8" × 10" (20cm × 25cm)
digital photograph illustration

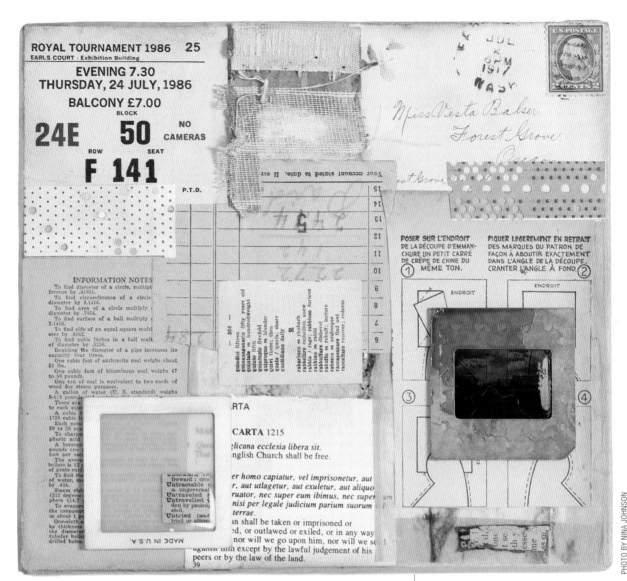

Remains of the Day | RUTH KRENING
5" × 6" (13cm × 15cm)
collage: book spines, vintage ephemera

Normal is not something to aspire to,
it is something to get away from.

JODIE FOSTER

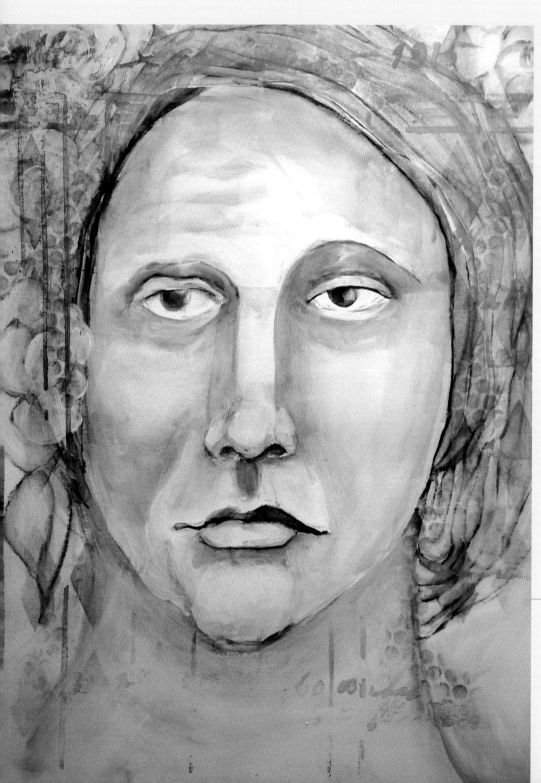

Beautiful young people are accidents of nature, but *beautiful old people are works of art.*

{ ELEANOR ROOSEVELT }

Youth Remembered
PAM CARRIKER
9" × 12"
(23cm × 30cm)
layered painting:
acrylics, graphite,
water-soluble media

> **Even if I knew that tomorrow the world would go to pieces,**
> *I would still plant my apple tree.*
>
> { MARTIN LUTHER }

I Would Still Plant My Apple Tree | JAN AVELLANA
8" × 10" (20cm × 25cm)
digital illustration

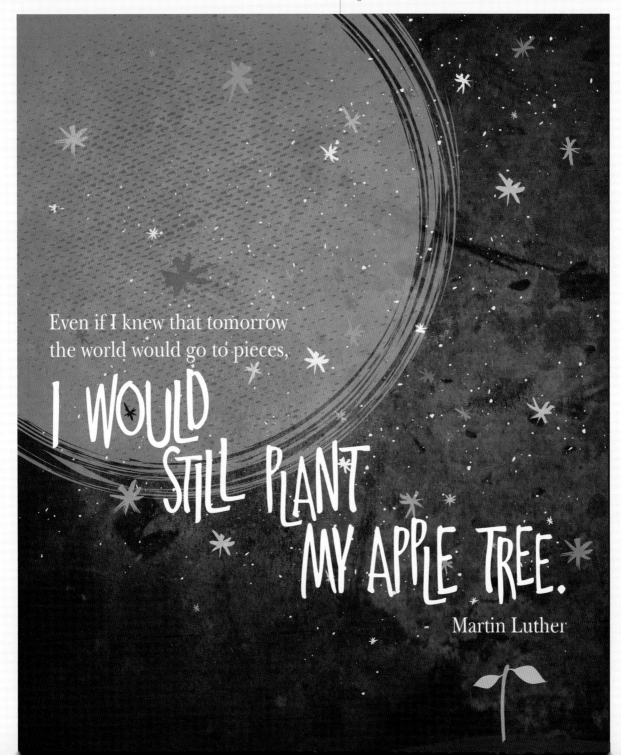

Even if I knew that tomorrow the world would go to pieces,

I WOULD STILL PLANT MY APPLE TREE.

- Martin Luther

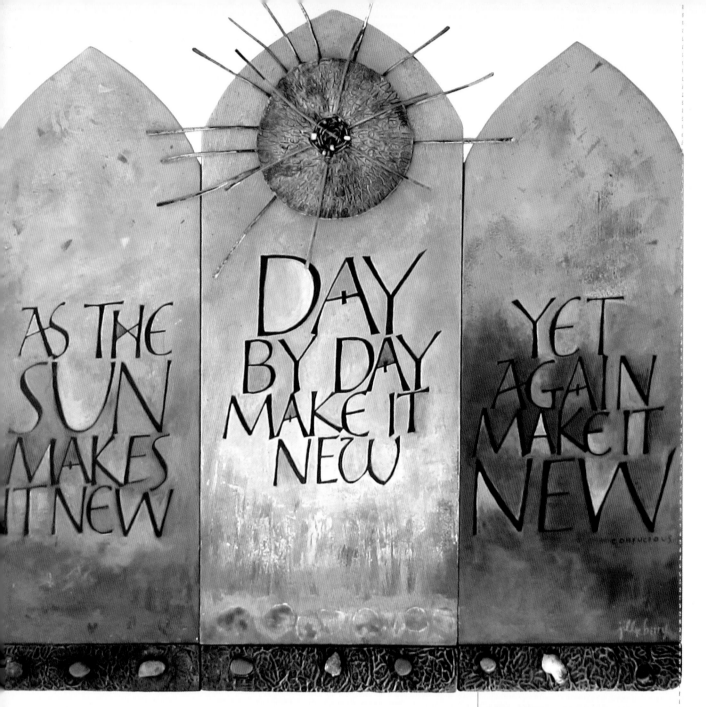

Make It New | JILL K. BERRY
19" × 19" (48cm × 48cm)
mixed media on wood: painting,
calligraphy, copper carving,
stone inlay

66

As the sun makes it new
Day by day make it new
Yet again make it new

EZRA POUND'S CONFUCIAN TRANSLATION

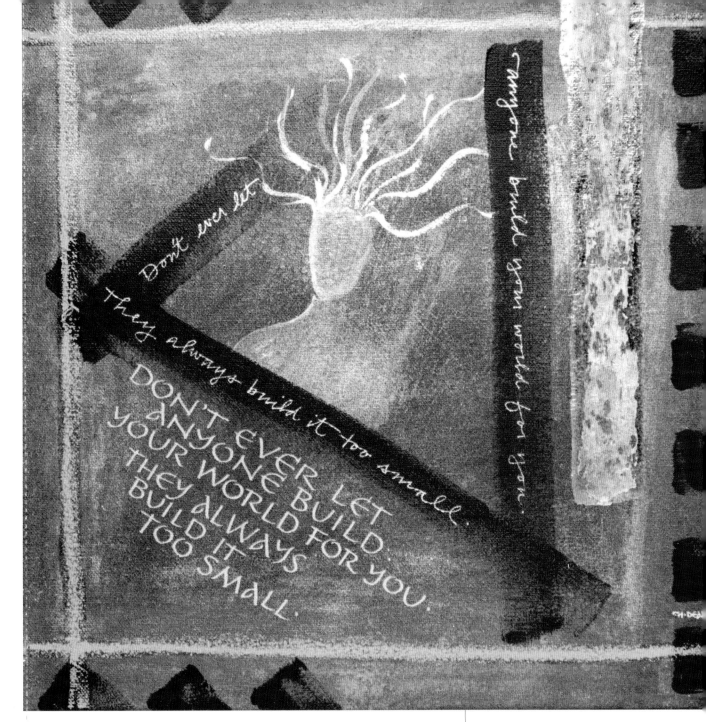

Your World | HOLLY DEAN
10" × 10" (25cm × 25cm)
painting: calligraphy, faux gilding, patinas

Don't ever let anyone *build your world*
for you. They always build it too small.

HOLLY DEAN

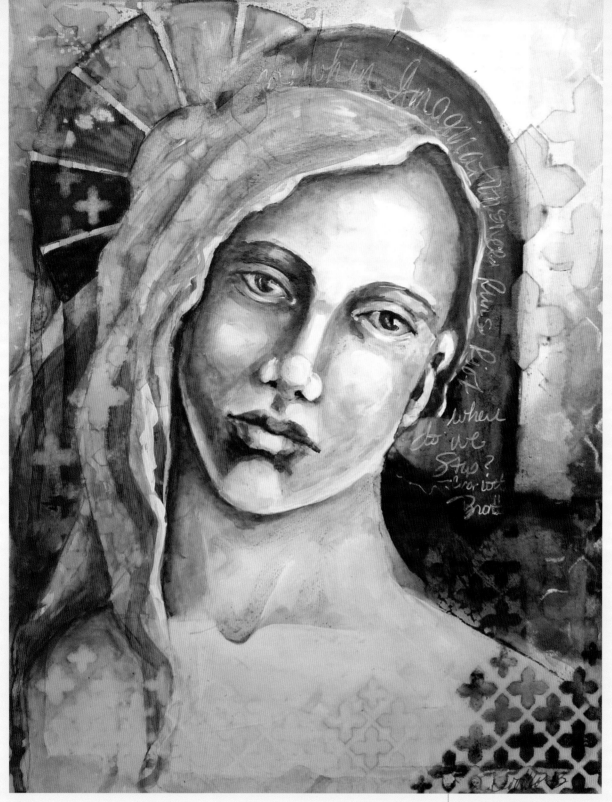

> " **Ah! When *imagination once runs riot*** where do we stop?

{ CHARLOTTE BRONTË }

My Imagination Runs Riot
PAM CARRIKER
9" × 12" (23cm × 30cm)
mixed-media painting: gesso,
acrylics, water-soluble pencil,
India ink pen

> **The aim of art is to represent not the outward appearance of things but their *inward significance.***
>
> { ARISTOTLE }

Green Mother Earth
ADEOLA DAVIES-AIYELOJA
8½" × 11"
(22cm × 28cm)
mixed-media painting
on paper

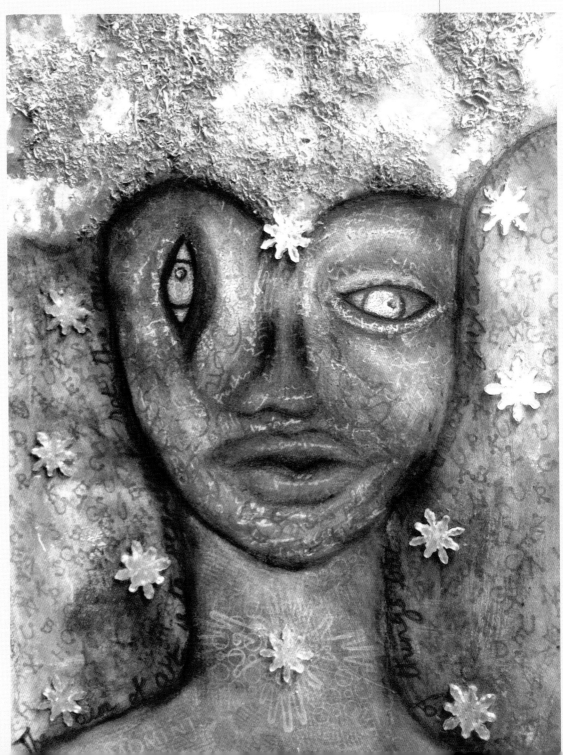

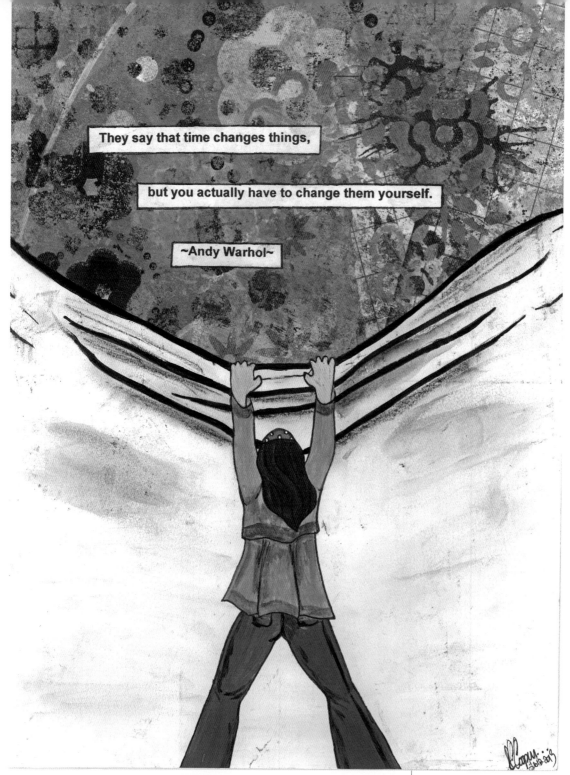

> **They say that time changes things,**
>
> **but you actually have to change them yourself.**
>
> **~Andy Warhol~**

Untitled | SARAH COOPER
8½" × 11¾" (22cm × 30cm)
mixed-media collage: painting

66 They say that time changes things, but you actually have to *change them yourself.*

{ ANDY WARHOL }

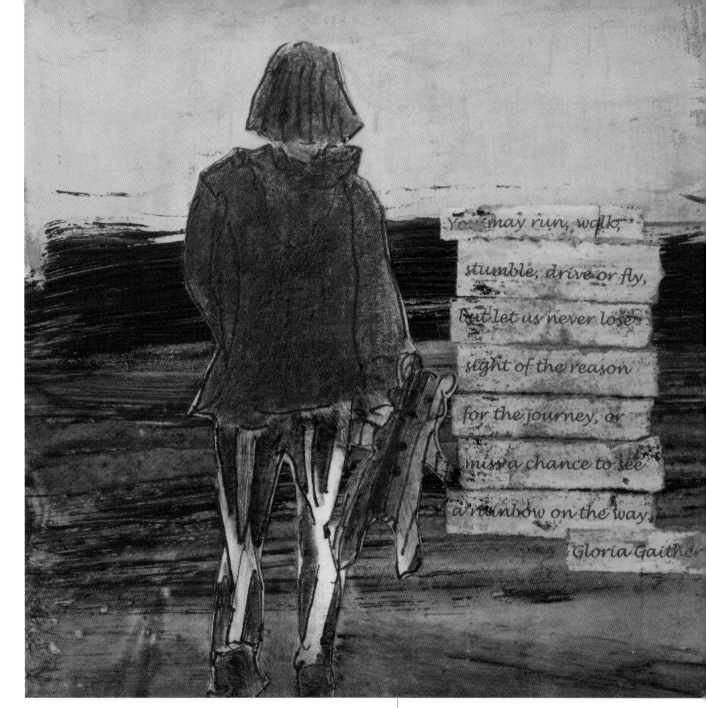

A Rainbow Gladdens My Heart | DEBORAH GUTHRIE
5" × 5" (13cm × 13cm)
collage: painting, drawing, glazing

" You may run, walk, stumble, drive or fly, but let us never lose sight of *the reason for the journey,* or miss a chance to see a rainbow on the way.

{ GLORIA GAITHER }

It isn't the great big pleasures that count the most; it's making a great deal out of *the little ones.*

JEAN WEBSTER

My Imagination Flies When I Open a Book
DEBORAH GUTHRIE
5" × 5" (13cm × 13cm)
collage: painting,
drawing, glazing

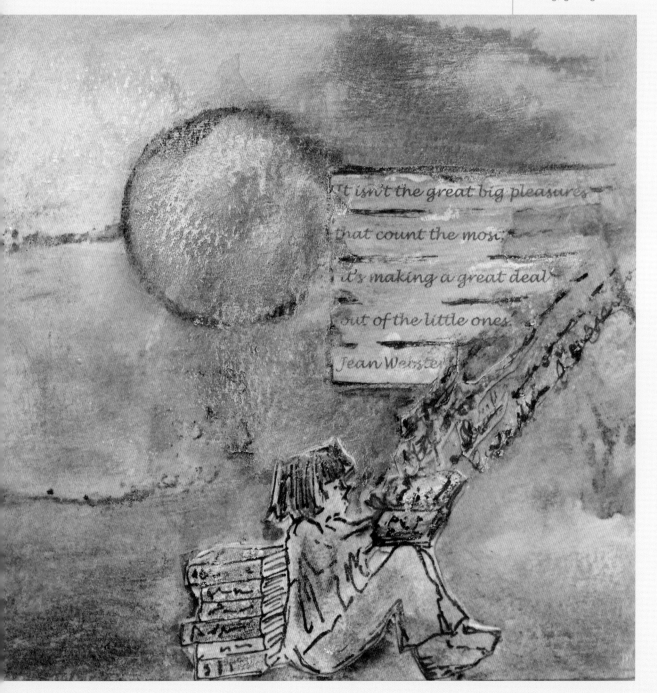

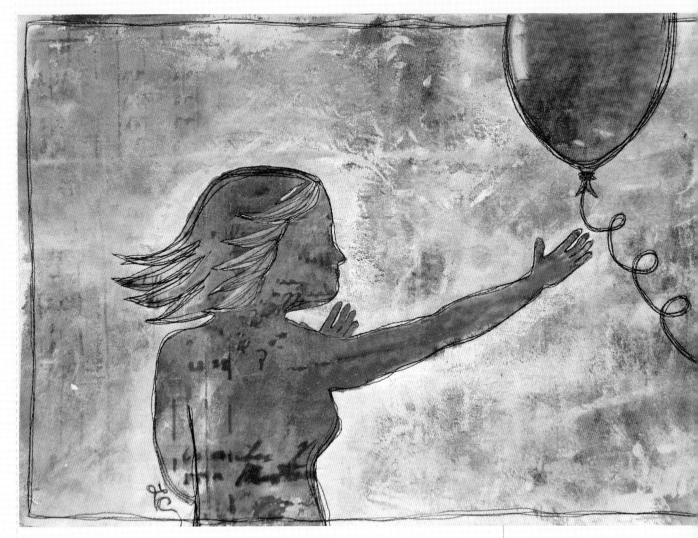

Grab Joy | LISA CHIN
20" × 14" (51cm × 36cm)
mono-printed fabric: handmade
and commercial stencils, acrylic
paint, thread

Let a joy keep you. *Reach out your hands* and take it when it runs by.

CARL SANDBURG

Everybody should have a chance
at a breathtaking piece of folly.

ELIZABETH TAYLOR

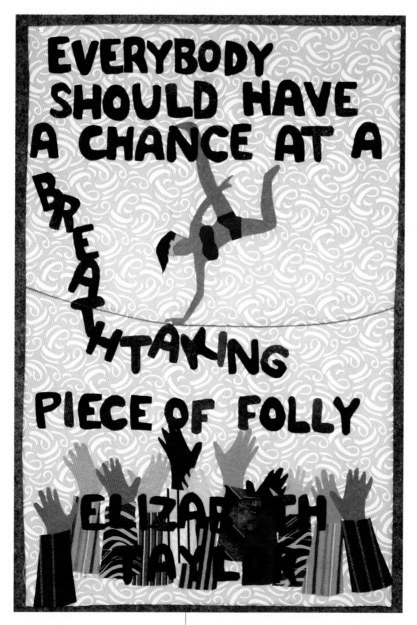

Breathtaking | CHRISTINE ADAMS
11½" × 17" (29cm × 43cm)
art quilt: Lutradur, cotton, muslin, appliqué,
dyeing, fusing, machine stitching and quilting

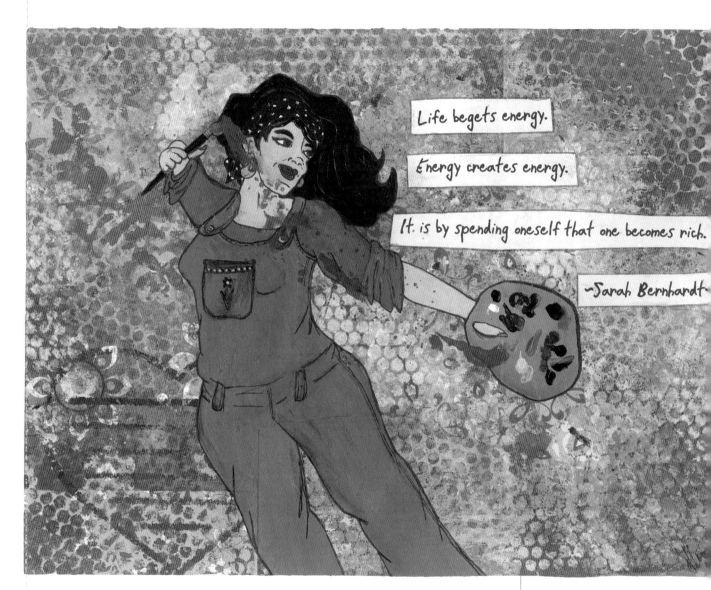

Untitled | SARAH COOPER
11" × 8½" (28cm × 22cm)
mixed-media collage: painting

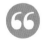

Life begets energy. Energy creates energy.
It is by spending oneself that we become rich.

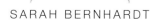

SARAH BERNHARDT

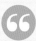

Your work is to discover your work
and then *with all your heart*
to give yourself to it.

The Discovery | DAYLE DOROSHOW
11" × 14" (28cm × 36cm)
fabric collage: transfer, stitching

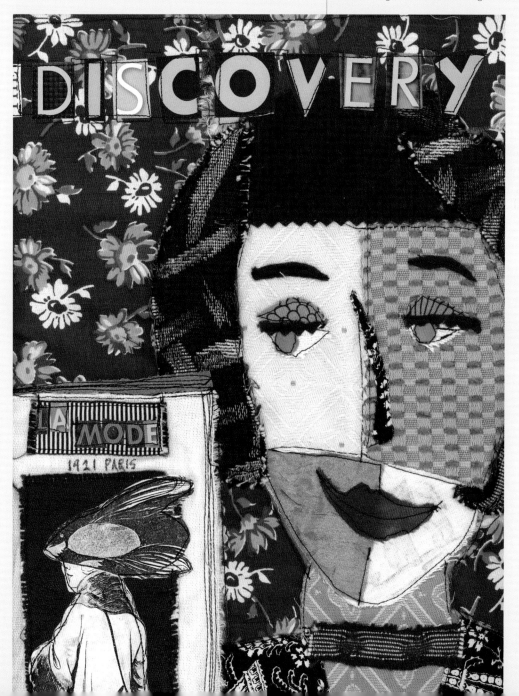

The handwritten text within the artwork reads:

i just love this quote! it makes me think of little charlie & littler get christopher, who will be arriving any day now. there is nothing more dear to me at this time than these two little guys. the joy that little charlie has brought so far is totally unexplainable. there is indeed something to be said about your children's children verses your own. don't get me wrong, i'm not saying that i love my children less than theirs, but there is less work, stress and responsibility, thus far more time to fully enjoy them. i have heard this from so many people!

The text within the heart reads: universe. the heart that breaks open contains the whole JOANNA MACY

The Heart That Breaks Open | INGRID DIJKERS
15" × 9" (38cm × 23cm)
art journal: collage and painting

> *The heart that breaks open*
> can contain the whole universe.

— JOANNA MACY

" **The object isn't to make art, it's to be in that state that wonderful state which** *makes art inevitable.*

{ ROBERT HENRI }

State of Mind
RACHEL STEWART
7½" × 14"
(19cm × 36cm)
assemblage:
newspaper, stick-
ers, found objects,
paper, acrylic
paint, beads

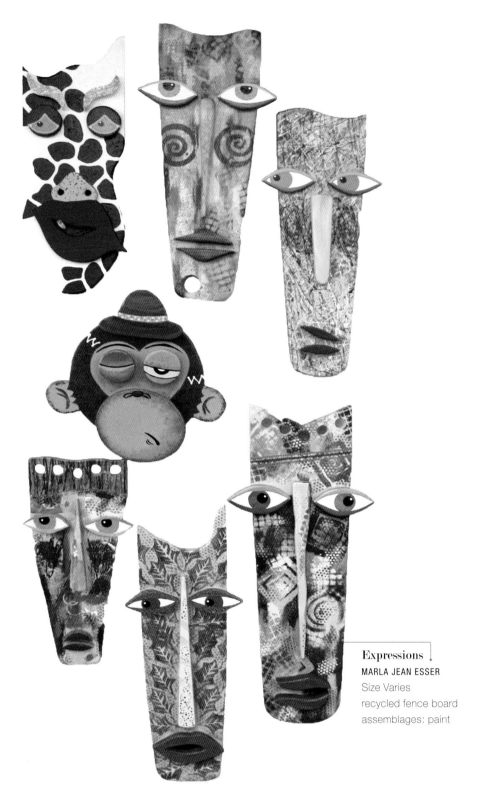

Expressions
MARLA JEAN ESSER
Size Varies
recycled fence board
assemblages: paint

"Why are you trying so hard to fit in when *you were born to stand out?*

{ IAN WALLACE }

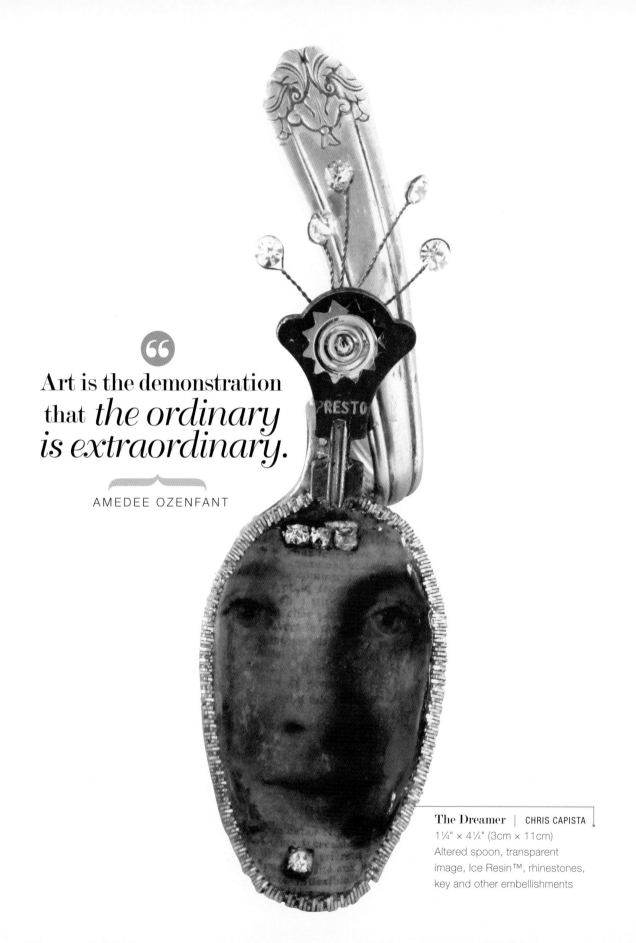

"
Art is the demonstration that *the ordinary is extraordinary.*

AMEDEE OZENFANT

The Dreamer | CHRIS CAPISTA
1¼" × 4¼" (3cm × 11cm)
Altered spoon, transparent
image, Ice Resin™, rhinestones,
key and other embellishments

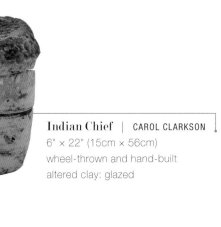

> **Tell me and I'll forget. Show me and I may not remember. Involve me and *I'll understand.***
>
> NATIVE AMERICAN PROVERB

Indian Chief | CAROL CLARKSON
6" × 22" (15cm × 56cm)
wheel-thrown and hand-built
altered clay: glazed

PHOTO BY HUNTER CLARKSON

We are cups, constantly and quietly being filled. The trick is knowing how to tip ourselves over and *let the beautiful stuff out.*

RAY BRADBURY

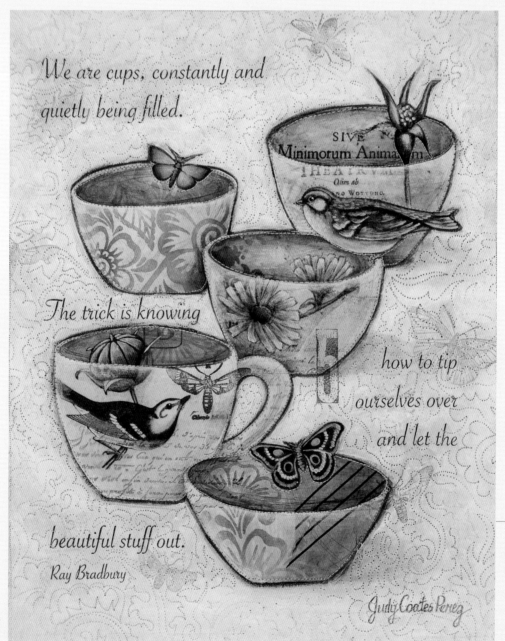

We Are Cups
JUDY COATES PEREZ
12" × 15"
(30cm × 38cm)
painted fabric collage:
rubber stamps,
printed Tissuetex, free
motion stitching

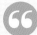

At the center of your being you have the answer; you *know who you are* and you know what you want.

LAO TZU

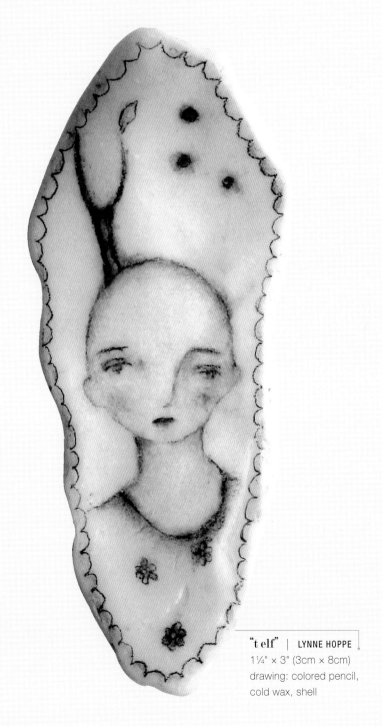

"t elf" | LYNNE HOPPE
1¼" × 3" (3cm × 8cm)
drawing: colored pencil,
cold wax, shell

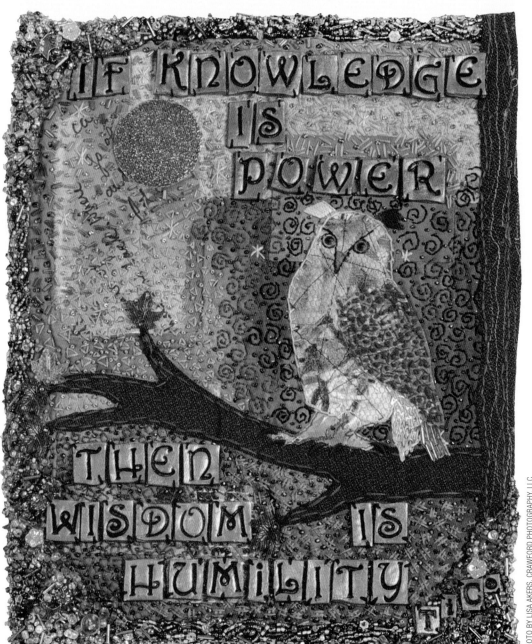

Subtle Blatancy | TICO
11" × 13½" (28cm × 34cm)
quilt: appliqué, hand and
machine embroidery, beading,
polymer clay stamping

"

If knowledge is power, then
wisdom is humility.

TICO

Life is a spell so exquisite that everything conspires to break it.

EMILY DICKINSON

Life Is a Spell | PAULA GUERIN
8" × 10" (20cm × 25cm)
collage and painting on wrapped canvas

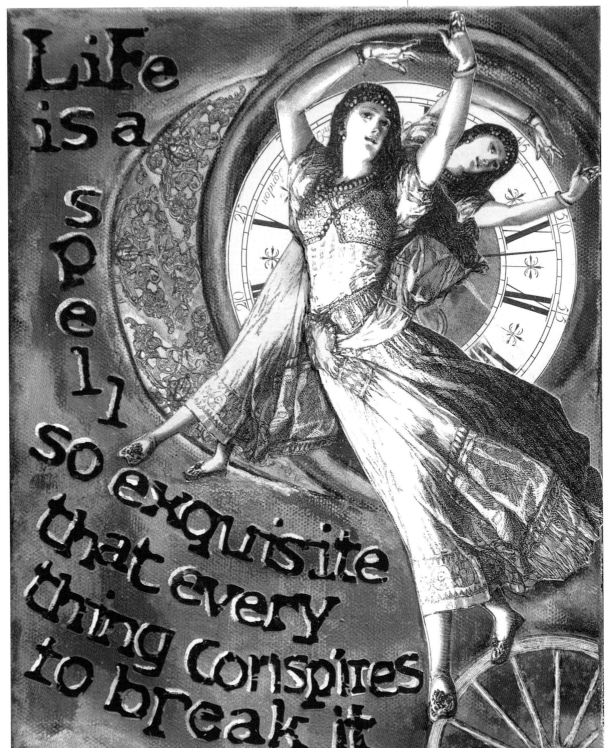

Fragments | BRIDGETTE GUERZON MILLS
8" × 8" (20cm × 20cm)
encaustic: collage, silk organza, photo, tea
paper, vintage French paper, oil paint

❝

And so the hand of time will take the fragments
of our lives and make out of life's remnants, as
they fall, *a thing of beauty after all.*

DOUGLAS MALLOCH

Conditions for creativity are to be puzzled; to concentrate; to accept conflict and tension; to be born everyday; to *feel a sense of self.*

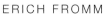

ERICH FROMM

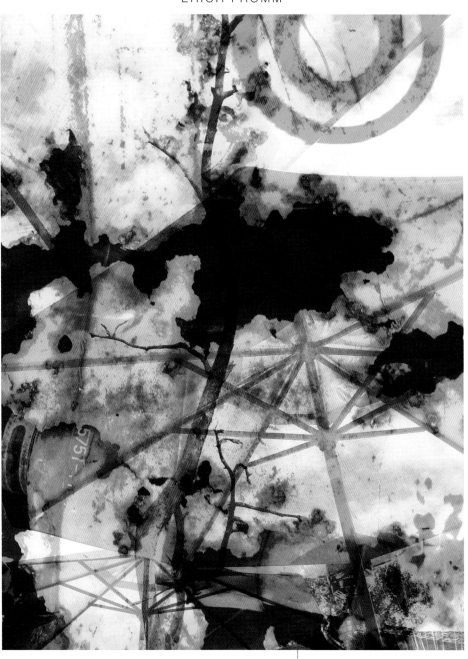

More Is Hidden | CHRIS COZEN
5" × 7" (13cm × 18cm)
digital collage: personal artwork

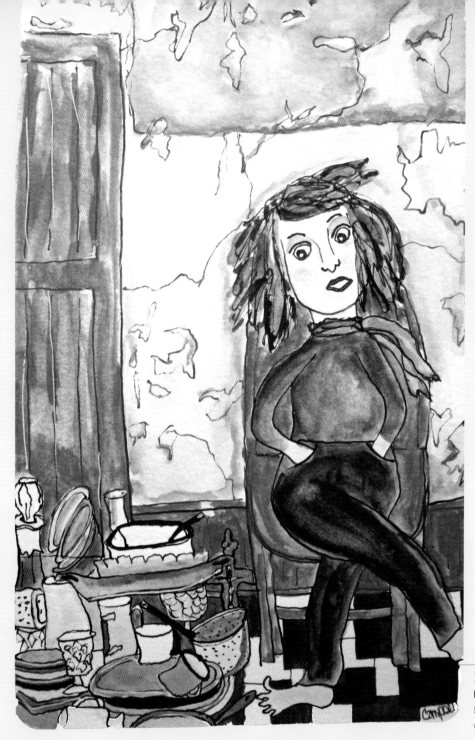

" **It *always seems impossible* until it's done.**

{ NELSON MANDELA }

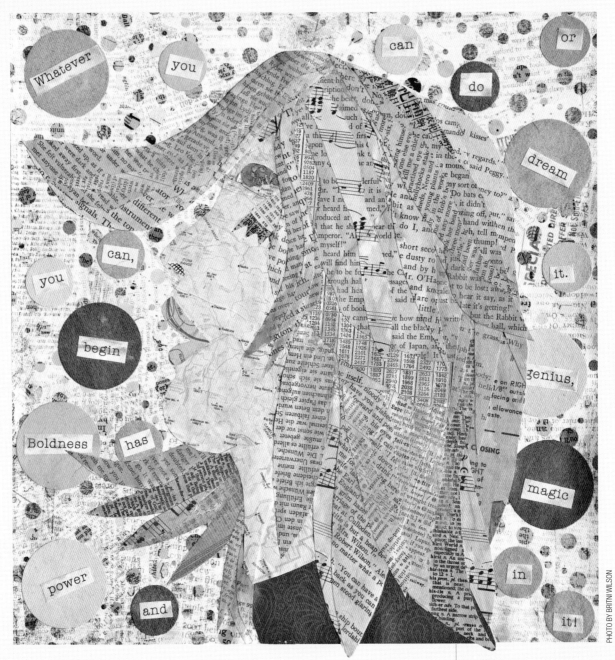

The collage contains the words: Whatever you can do or dream you can, begin it. Boldness has genius, power, and magic in it!

Do It Now! | CHERYL ALT
12" × 12" (30cm × 30cm)
collage: vintage papers, paint

" **Whatever you can do or dream you can, begin it. Boldness has genius, power, and magic in it.** *Begin it now.*

{ JOHANN WOLFGANG VON GOETHE }

Untitled | LOIS PARKS DECASTRO
9" × 9" (23cm × 23cm)
hand calligraphy and digital art:
pens, sumi ink, acrylic paint

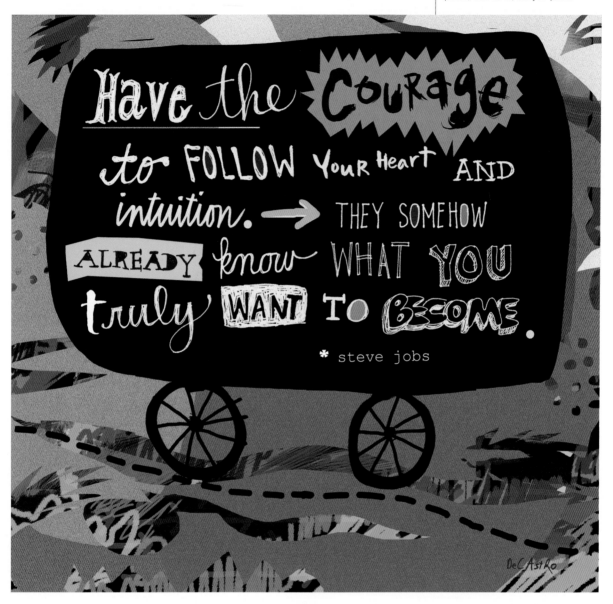

Have the courage to *follow your heart and intuition.* They somehow already know what you truly want to become. Everything else is secondary.

STEVE JOBS

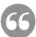

When you *follow your bliss* . . . doors will open where you would not have thought there would be doors, and where there wouldn't be a door for anyone else.

JOSEPH CAMPBELL

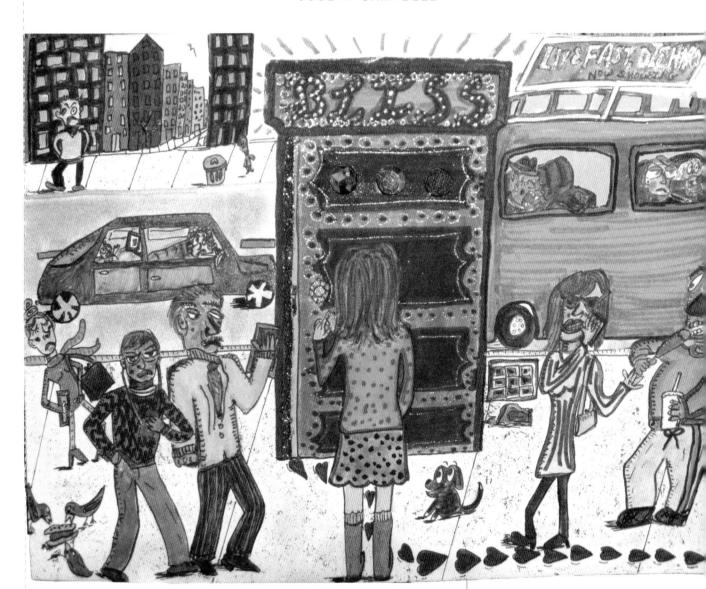

Follow Your Bliss | JILL HEJL
12" × 9" (30cm × 23cm)
drawing and painting on watercolor paper

Beauty is *the sense of life* and the awe one has in its presence.

{ WILLA CATHER }

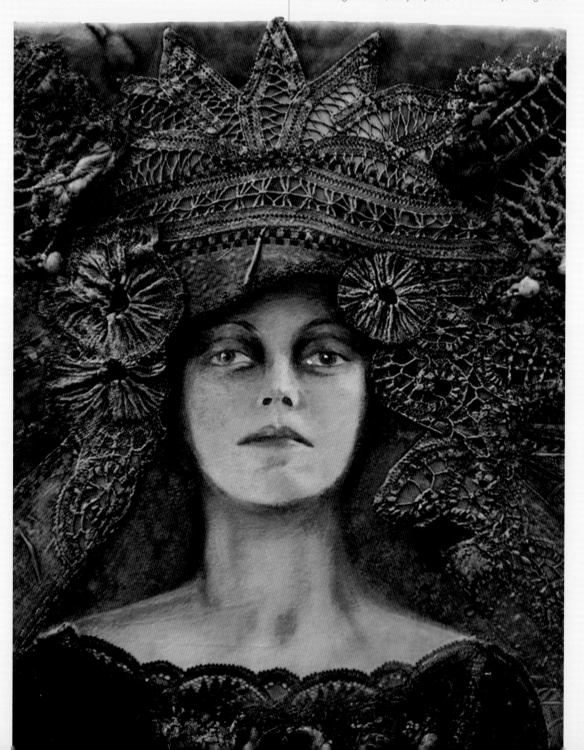

A Thread That Runs Through | PEARL RED MOON
21½" × 25½" (55cm × 65cm)
fiber collage: fabric, acrylic paint, embroidery, felting fibers

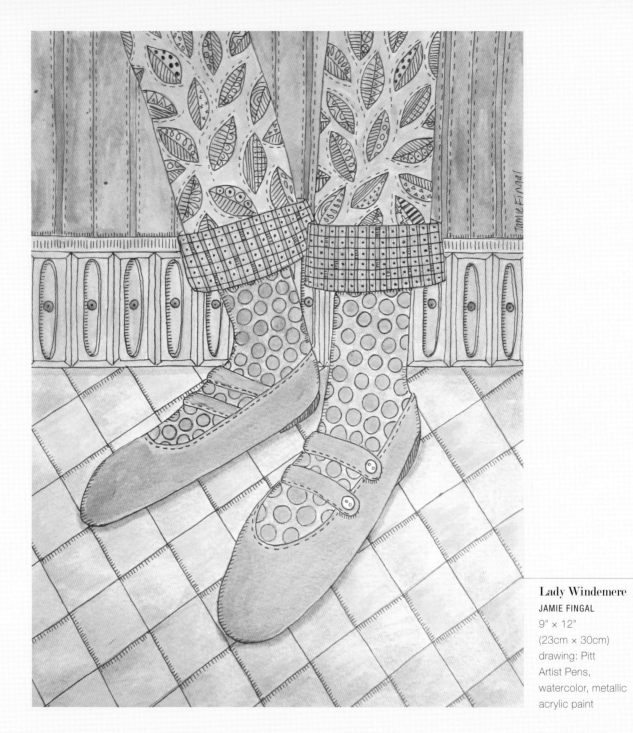

Lady Windemere
JAMIE FINGAL
9" × 12"
(23cm × 30cm)
drawing: Pitt
Artist Pens,
watercolor, metallic
acrylic paint

❝ She had a curious love of green, which in individuals is always the sign of *a subtle artistic temperament.*

{ OSCAR WILDE }

Thousands of *things go right for you* every day.

ROB BREZSNY

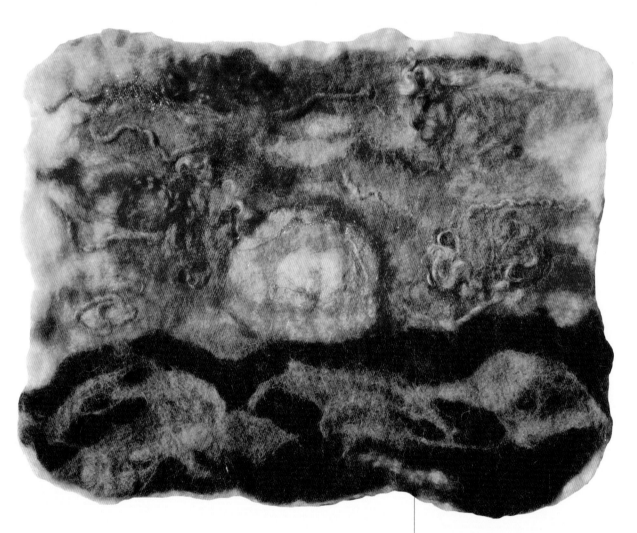

Sunrise Serenity | LUCY PEARCE HUGHES
14" × 11" (36cm × 28cm)
wet felting: needle felting, wool

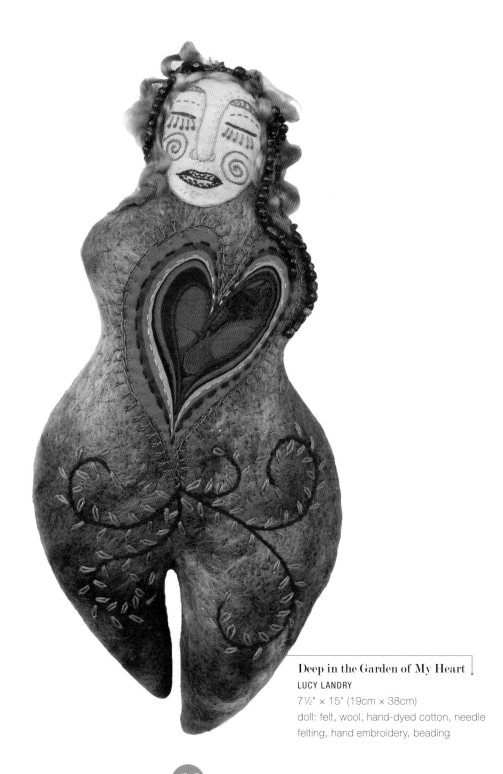

Deep in the Garden of My Heart
LUCY LANDRY
7½" × 15" (19cm × 38cm)
doll: felt, wool, hand-dyed cotton, needle felting, hand embroidery, beading

❝

The most beautiful things in the world cannot be seen or even touched. *They must be felt with the heart.*

HELEN KELLER

66 **Artists can *color the sky red* because they know that it is blue.**

{ JULES FEIFFER }

Color the Sky | STACEY MERRILL
8" × 10" (20cm × 25cm)
mixed media: drawing, painting,
digital manipulation

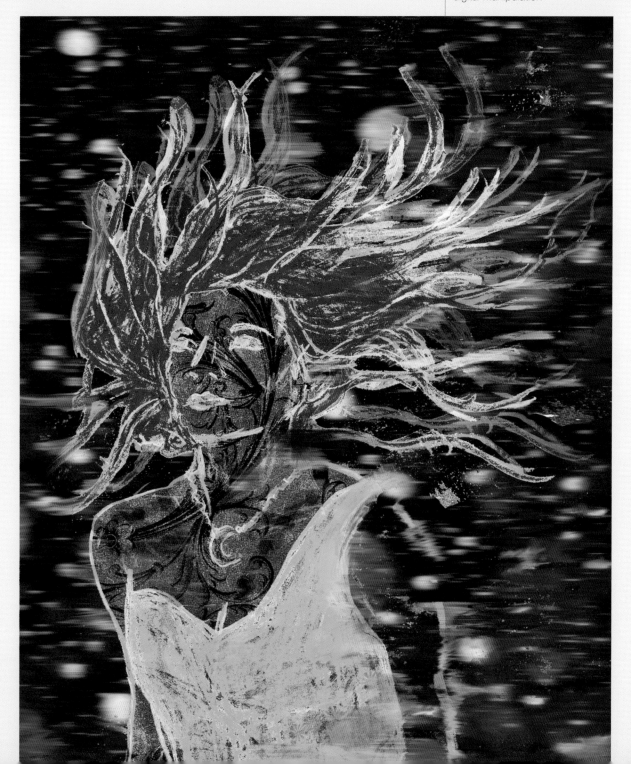

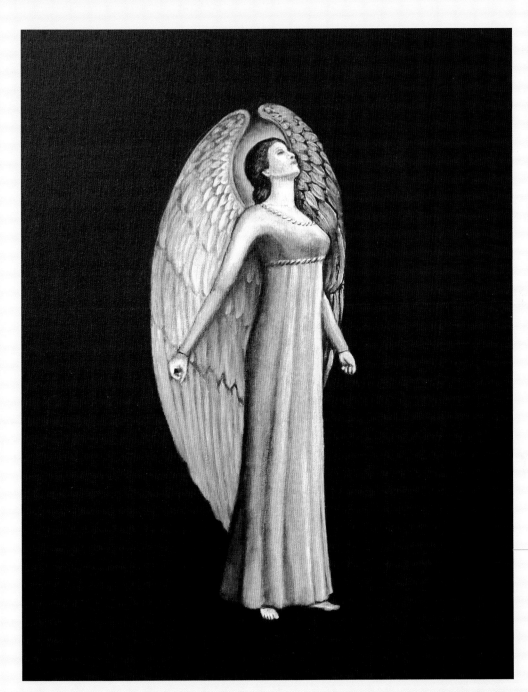

" If the angel deigns to come it will be because you have convinced her, not by tears but by your humble resolve to be *always beginning;* to be a beginner.

{ RAINER MARIA RILKE }

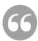

> It's not what you gather, but what you scatter that tells what kind of *life you have lived.*

HELEN WALTON

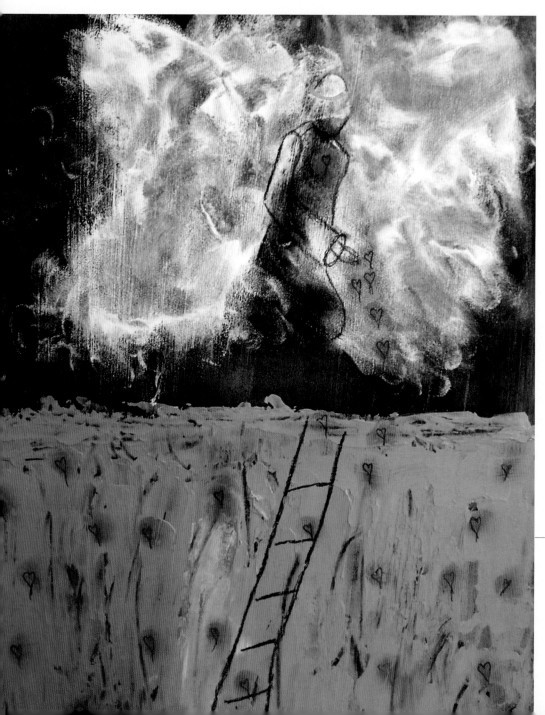

Scattered Hearts
JOYCE ADOMAITIS/
JADIVAJOY
8" × 10"
(20cm × 25cm)
mixed media:
acrylic paint
and pencil

68

Invincible Summer
PATTI MONROE-MOHRENWEISER
8" × 10" (20cm × 25cm)
encaustic: wax, shellac
burn, image transfer

In the midst of winter, I found there was, within me, an *invincible summer.*

ALBERT CAMUS

"
Art washes away from the soul the dust of everyday life.

PABLO PICASSO

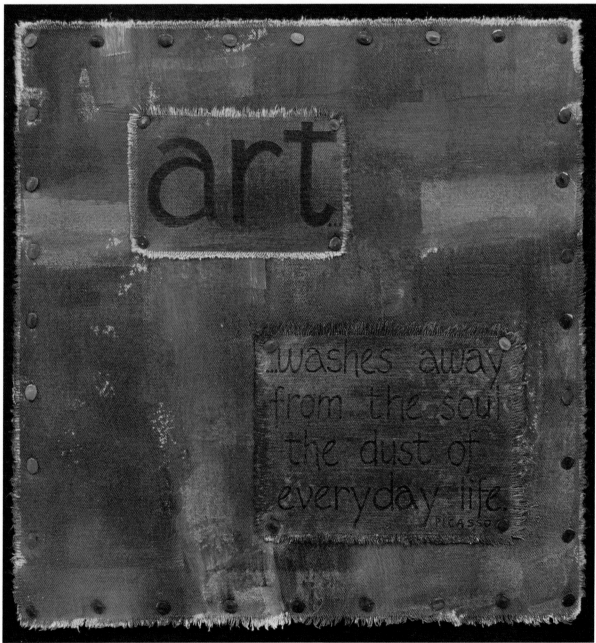

Dusting | CHERYL GREENSTREET
13" × 14" (33cm × 36cm)
painted canvas: markers,
mounted on silk over primed MDF

This and That
RUTH KRENING
7" × 8"
(18cm × 20cm)
painting: acrylic
paint on text paper
mounted on black
cardstock

Serendipity. Look for something, find
something else, and realize that what you've
found is more suited to your needs than what
you thought you were looking for.

LAWRENCE BLOCK

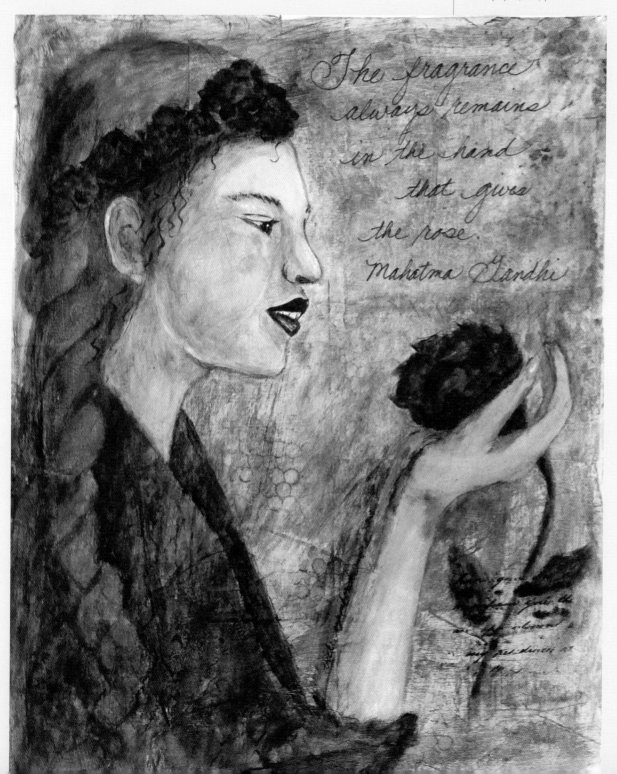

"The fragrance always remains in *the hand that gives* the rose.

{ MAHATMA GANDHI }

The Rose | VICKI SZAMBORSKI
11" × 14" (28cm × 36cm)
painting: drawing, collage,
stenciling, writing, acrylic paint,
tissue paper, ink, pen

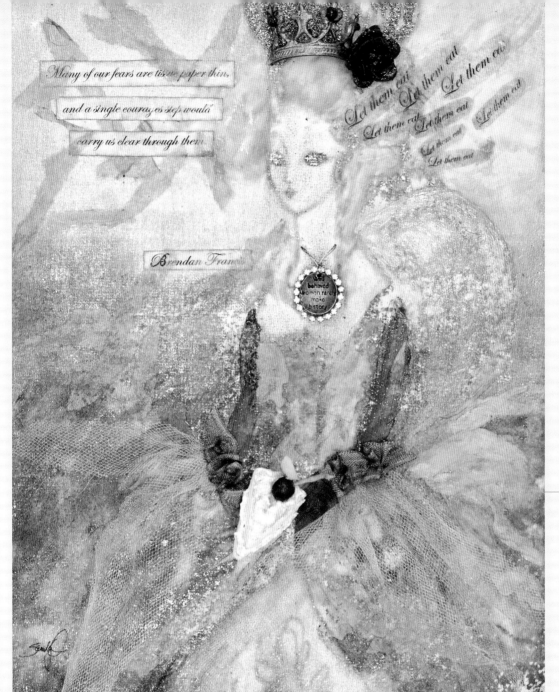

Many of our fears are tissue paper thin,

and a single courages step would

carry us clear through them

Let them eat

Brendan Fran

Let Them Eat
SANDY OHLSON
8" × 10"
(20cm × 25cm)
mixed media:
encaustic, transfer,
painting, clay
sculpting, TAP
Transfer Artist
Paper, beeswax,
German glass
glitter, paper clay,
ephemera

PHOTO BY ANNE LORYS

" Many of our fears are tissue-paper-thin, and a single *courageous* step would carry us clear through them.

{ BRENDAN FRANCIS }

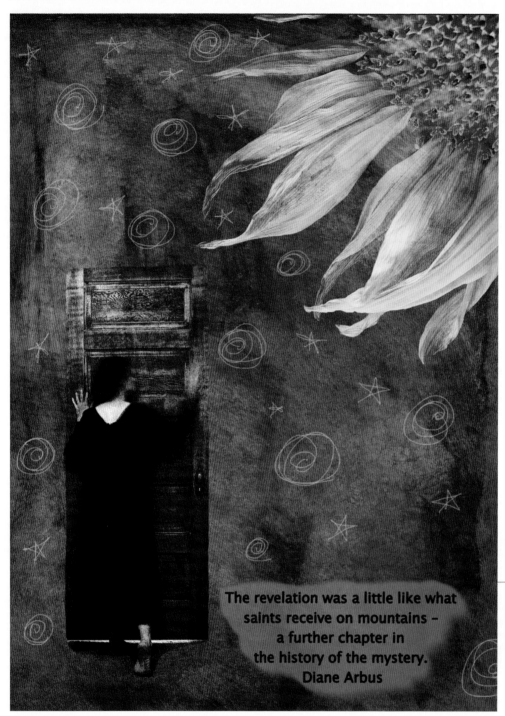

The revelation was a little like what
saints receive on mountains –
a further chapter in
the history of the mystery.
Diane Arbus

The History
of the Mystery
LESLIE LEVENSON
8½" × 11⅛"
(22cm × 30cm)
digital collage:
photography,
watercolor

> The revelation was a little like what saints
> receive on mountains—a further chapter
> in the *history of the mystery.*

{ DIANE ARBUS }

> **" There was *never a place for her* in the ranks of the terrible, slow army of the cautious. She ran ahead, where there were no paths.**
>
> { DOROTHY PARKER }

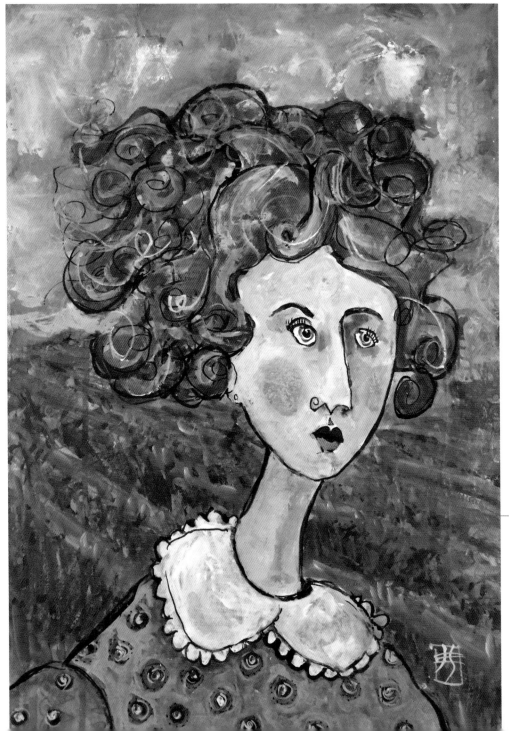

Emily Hurries
Home in Time
for Tea
JOANIE SPRINGER
8" × 12"
(20cm × 30cm)
painting: gouache,
paper mounted on
wood panel

❝ Your living is determined not so much by what life brings to you as the attitude you _bring to life._

{ KHALIL GIBRAN }

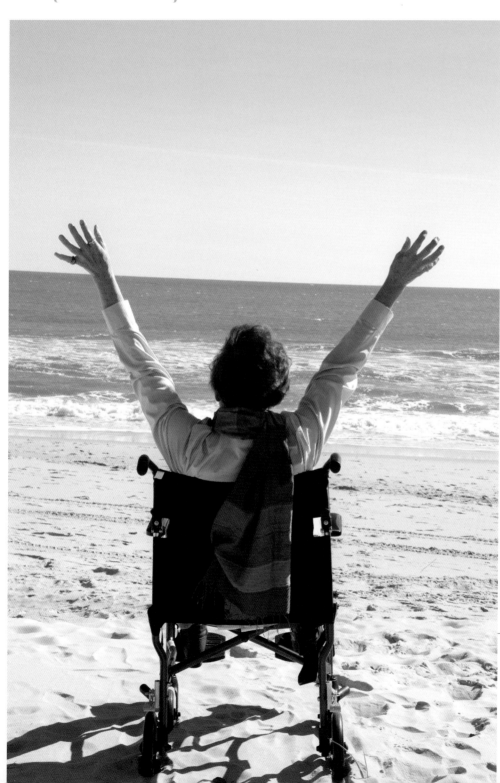

Joy on Wheels
SUSAN E. HANCE
9" × 12"
(23cm × 30cm)
digital photograph

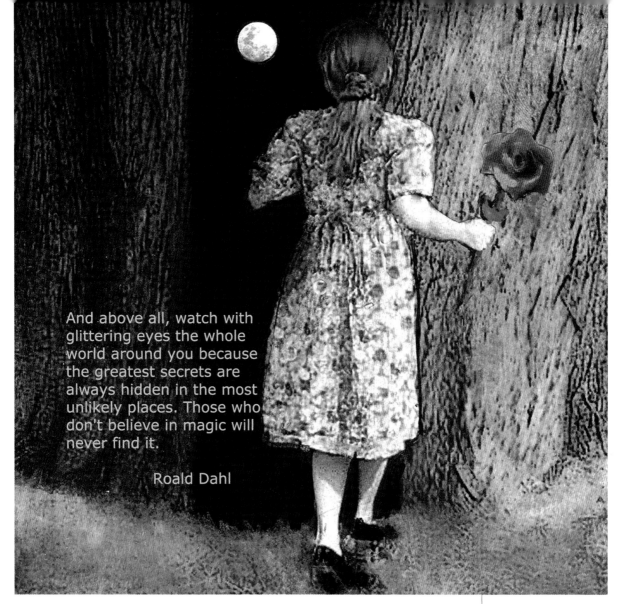

And above all, watch with glittering eyes the whole world around you because the greatest secrets are always hidden in the most unlikely places. Those who don't believe in magic will never find it.

Roald Dahl

Whispers of the Moon
GINA LOUTHIAN-STANLEY
6" × 6" (15cm × 15cm)
mixed-media collage:
digital collage, vintage
photograph, painting

❝ And above all, *watch with glittering eyes* the whole world around you because the greatest secrets are always hidden in the most unlikely places.

{ROALD DAHL}

"*Free your heart.* Travel like the moon among the stars.

BUDDHA

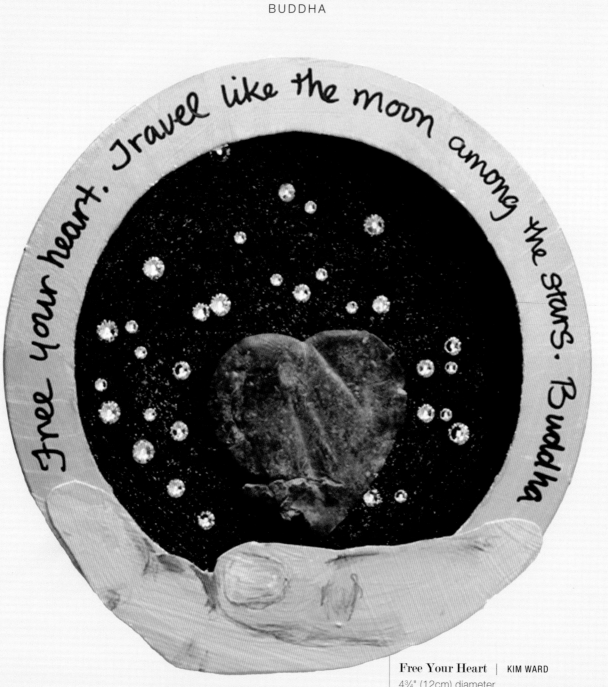

Free Your Heart | KIM WARD
4¾" (12cm) diameter
assemblage: painting, drawing, acrylic,
colored pencil, found objects, crystals

Other Than Human | DORIS ARNDT
9" × 12" (23cm × 30cm)
watercolor: hand lettering, salt resist,
ink, colored pencil, silk flowers

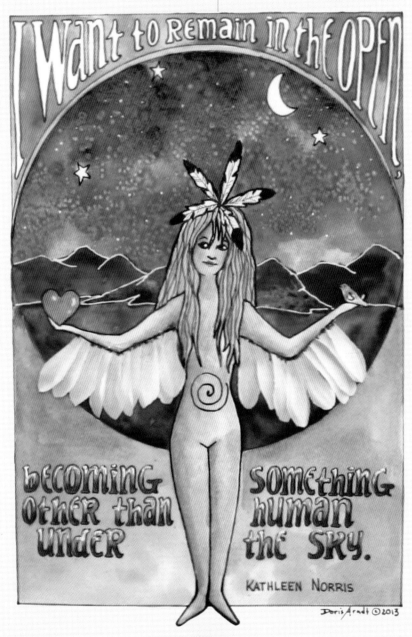

> I want to remain in the open becoming something *other than human* under the sky.

KATHLEEN NORRIS

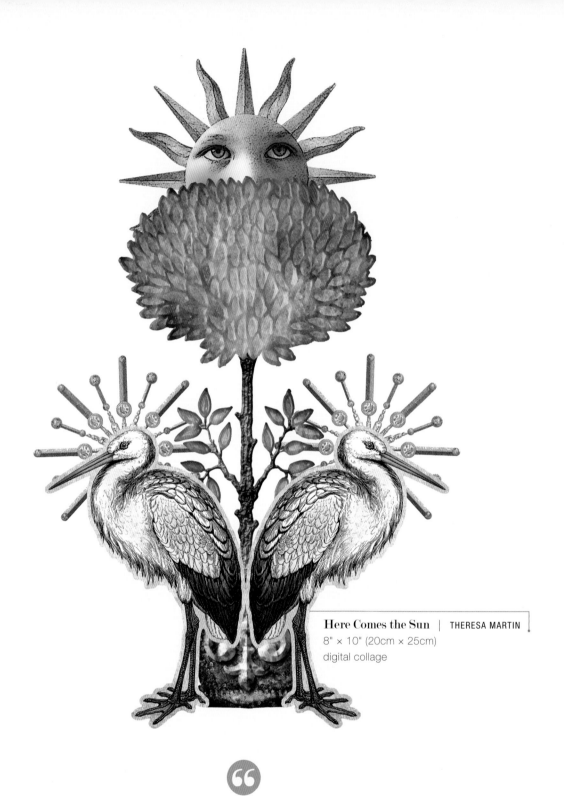

Here Comes the Sun | THERESA MARTIN
8" × 10" (20cm × 25cm)
digital collage

The breeze at dawn has *secrets* to tell you,
don't go back to sleep.

— RUMI

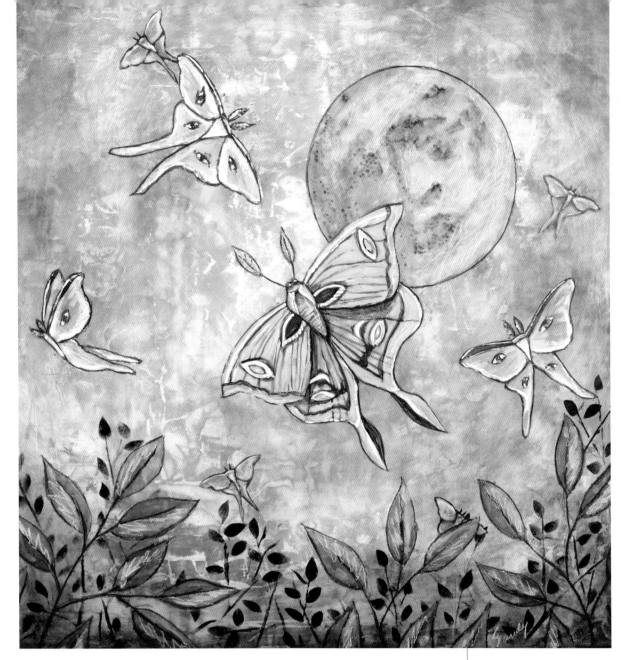

Luna | SANDY LUPTON
24" × 24" (61cm × 61cm)
painting: deconstructed
screen print, drawing, collage

She had *found a jewel* down inside
herself and she had wanted to walk where
people could see her and gleam it around.

ZORA NEALE HURSTON

"If you don't *imagine* nothing ever happens at all.

{ JOHN GREEN }

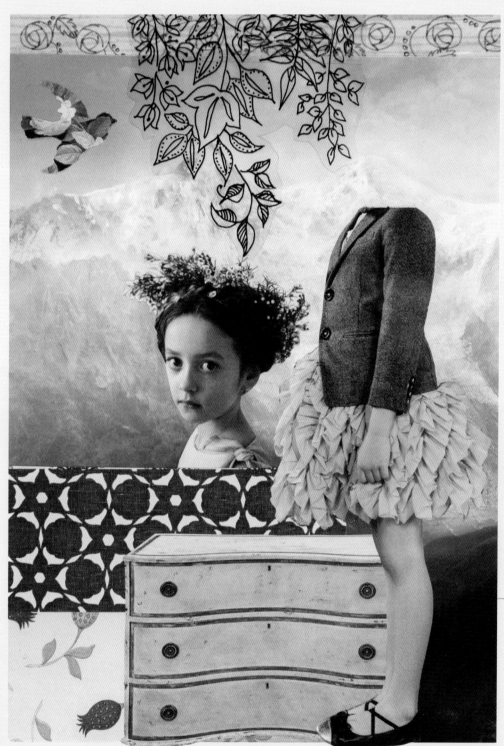

In My Secret Garden
MICHELLE CASEY
6" × 8"
(15cm × 20cm)
mixed-media
collage: magazine
fragments,
acetate, markers

Muzzle
JUDITH MANGIAMELI
8½" × 10"
(22cm × 25cm)
collage: paper
on wood

" **Will is to *grace* as the horse is to the rider.**

{ SAINT AUGUSTINE }

66 The well of Providence is deep. It's the
buckets we bring to it that are small.

{ MARY WEBB }

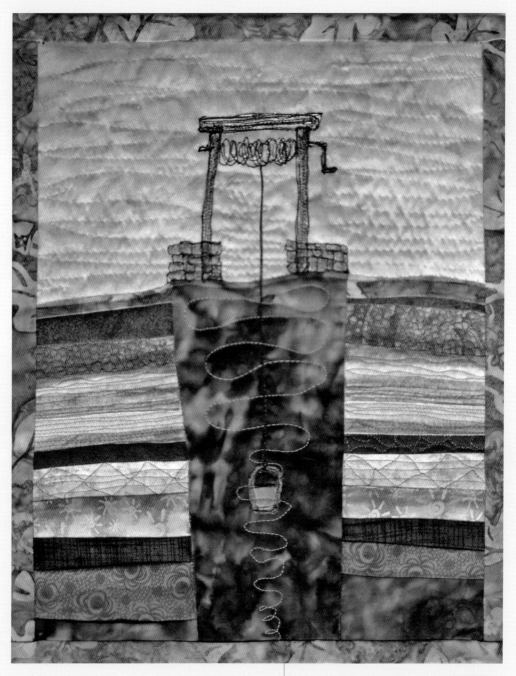

Oasis of Refreshment | CATHERINE MARTIN
10" × 13" (25cm × 33cm)
quilt: cotton, painted background, machine
pieced, free motion quilting

❝ The color of springtime is in the flowers; the color of winter is in *the imagination.*

{ TERRI GUILLEMETS }

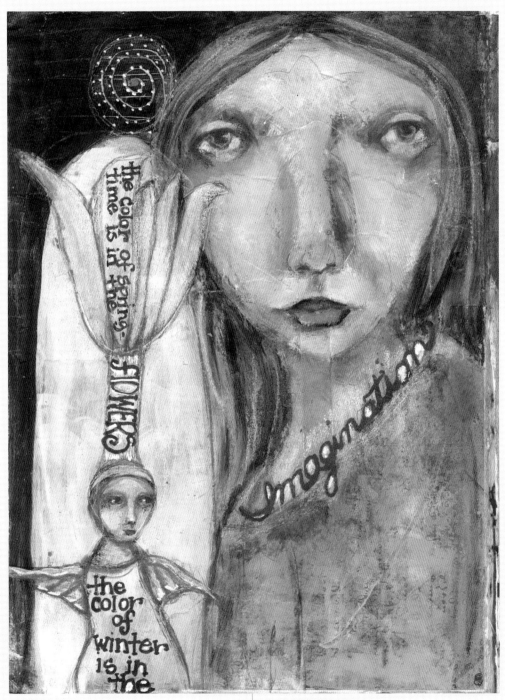

The Color of Spring | KAREN O'BRIEN
6½" × 9" (17cm × 23cm)
collage: painting, drawing, acrylic, watercolor, pencil

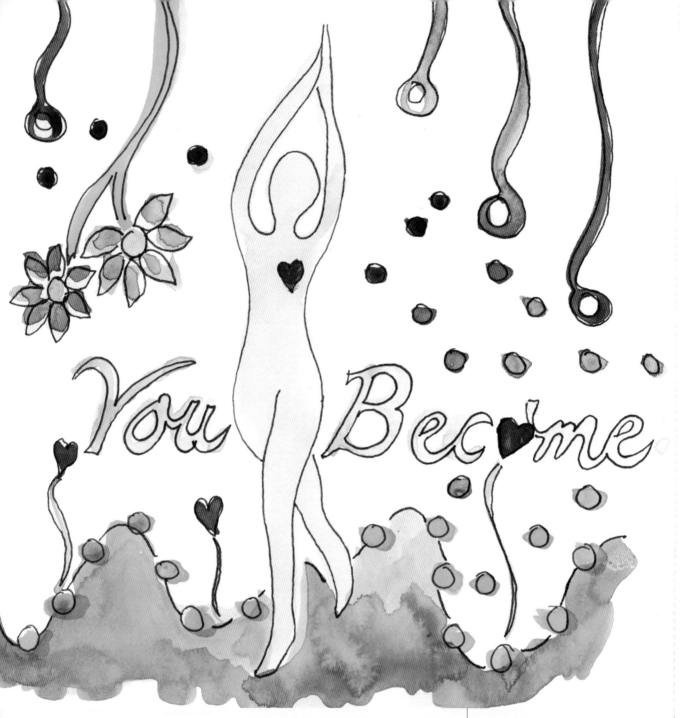

You Become | SHARON HENDRY
7½" × 8" (19cm × 20cm)
drawing: watercolor, pen and ink

" It doesn't happen all at once. *You become.*
It takes a long time.

{ MARGERY WILLIAMS }

> **We have to *dare to be ourselves,*** however frightening or strange that self may prove to be.

{MAY SARTON}

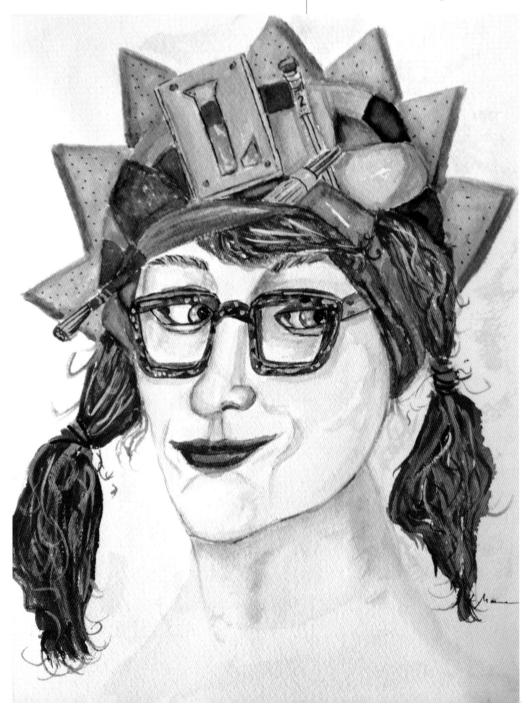

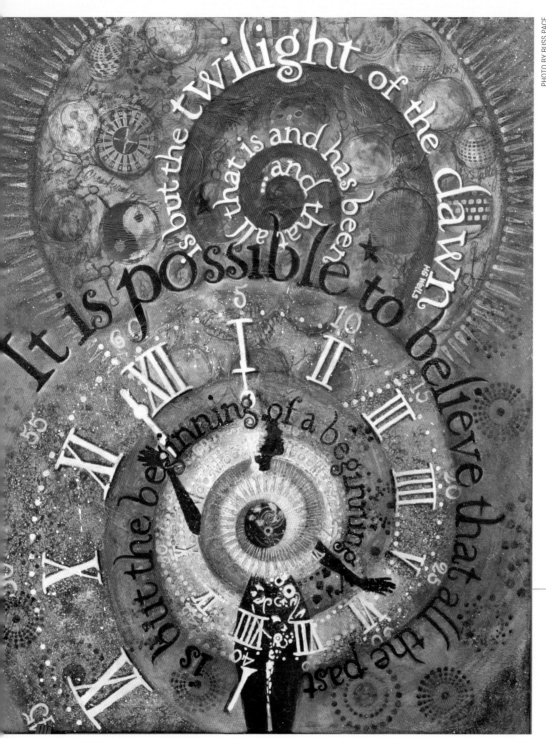

Beginning of a
Beginning
MICHELLE TOMPKINS
24" × 36"
(61cm × 91cm)
collage: sketching,
painting, acrylic
paint, water-
soluble crayon

" *The past is the beginning*
of the beginning and all that is and has
been is but the twilight of the dawn.

{ H.G. WELLS }

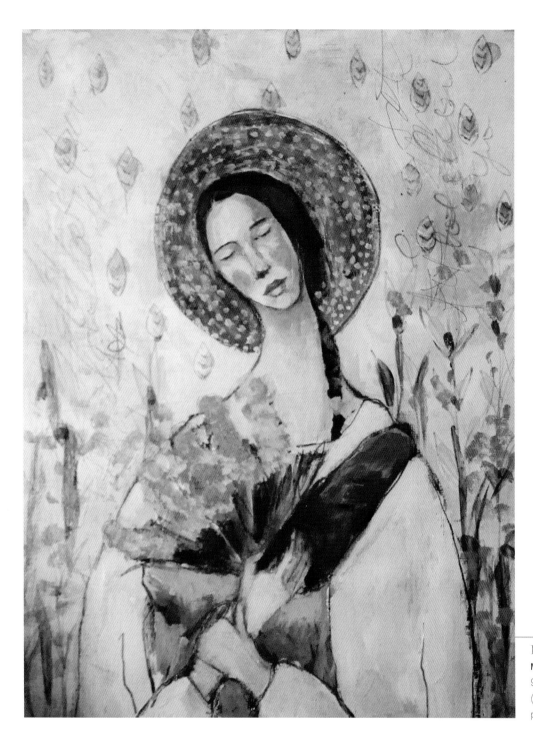

Feed the Soul
MISTY MAWN
9" × 12"
(23cm × 30cm)
painting: acrylic

66 **If you have but two coins, use one for bread to feed the body and the other for hyacinths to** *feed the soul.*

{ PERSIAN PROVERB }

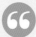

The greatest good you can do for another is not just to *share your riches,* but to reveal to him his own.

BENJAMIN DISRAELI

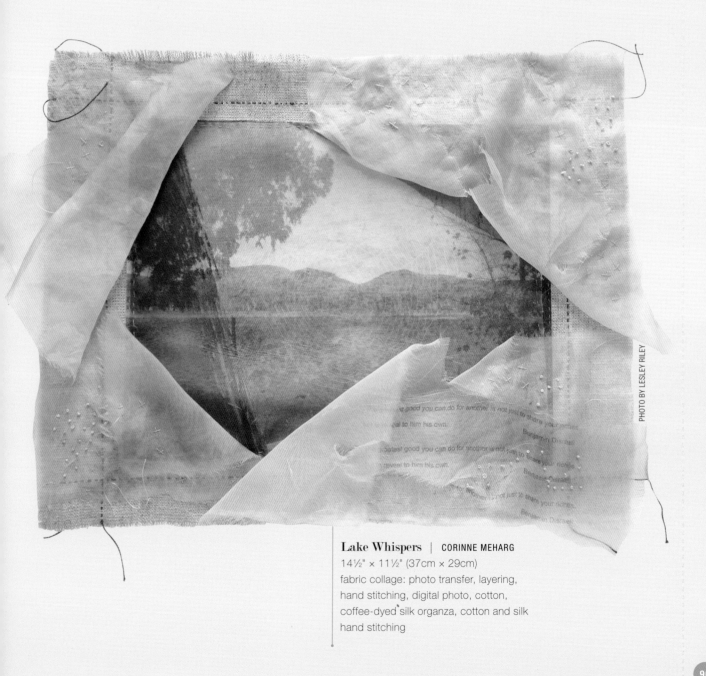

Lake Whispers | CORINNE MEHARG
14½" × 11½" (37cm × 29cm)
fabric collage: photo transfer, layering,
hand stitching, digital photo, cotton,
coffee-dyed silk organza, cotton and silk
hand stitching

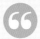

Learn to *observe the ordinary.*
That's where you'll find the answers.

LESLEY RILEY

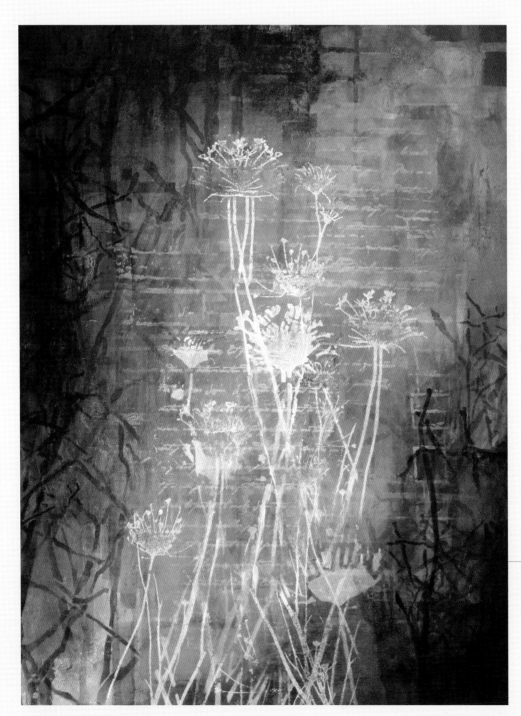

In This Moment
MARY BETH SHAW
12" × 16"
(30cm × 41cm)
mixed-media
painting: acrylic
paint, glazes, sten-
cils, Thermofax,
rubber stamps

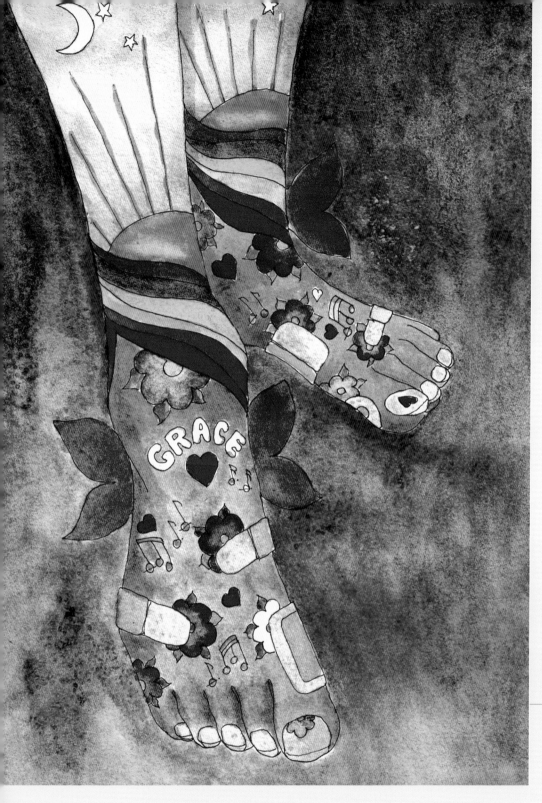

Grace
CHERYL STEVENSON
9" × 12"
(23cm × 30cm)
watercolor

66 **In life as in dance,** *Grace glides* **on blistered feet.**

{ ALICE ABRAMS }

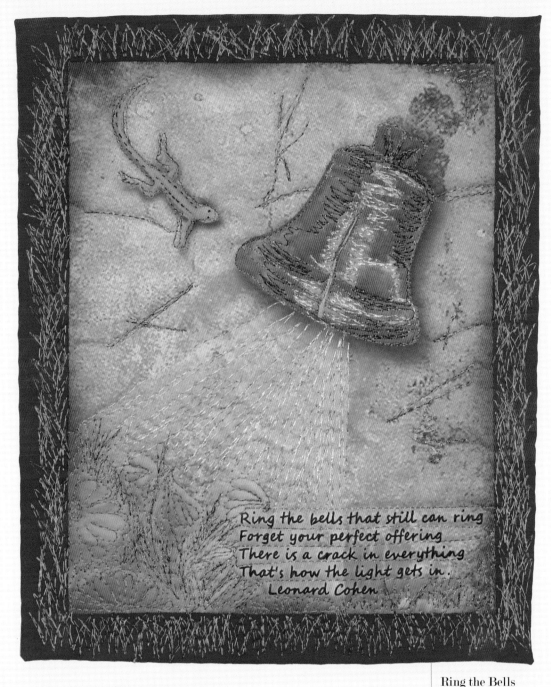

Ring the Bells
LINDA TEDDLIE MINTON
8" × 10"
(20cm × 25cm)
original digital
collage: painting,
ink, hand and
machine stitched

> *Ring the bells* that still can ring
> Forget your perfect offering
> There is a crack in everything
> That's how the light gets in.

{ LEONARD COHEN }

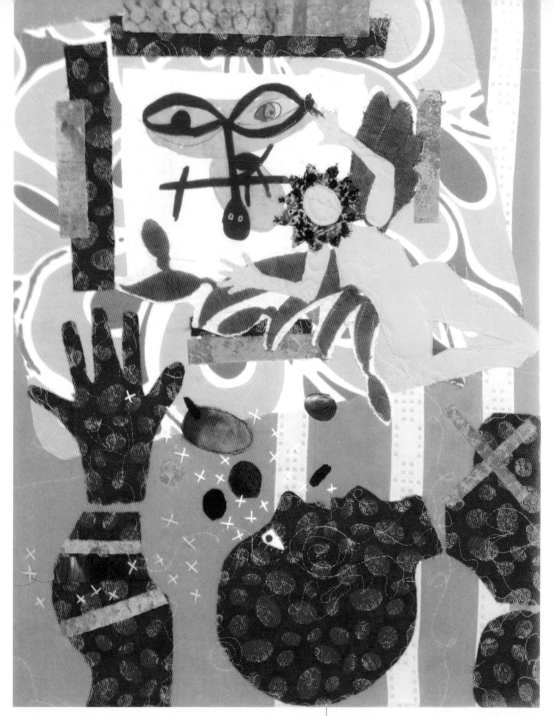

When You Look at Art | SUSIE MONDAY
16" × 24" (41cm × 61cm)
quilt: fabric, screen printed dyed, fused,
machine and hand stitched

When we look at art we are *looking for ourselves.*

{LESLEY RILEY}

Art is not a handicraft, it is the transmission of feeling the artist has experienced.

{ LEO TOLSTOY }

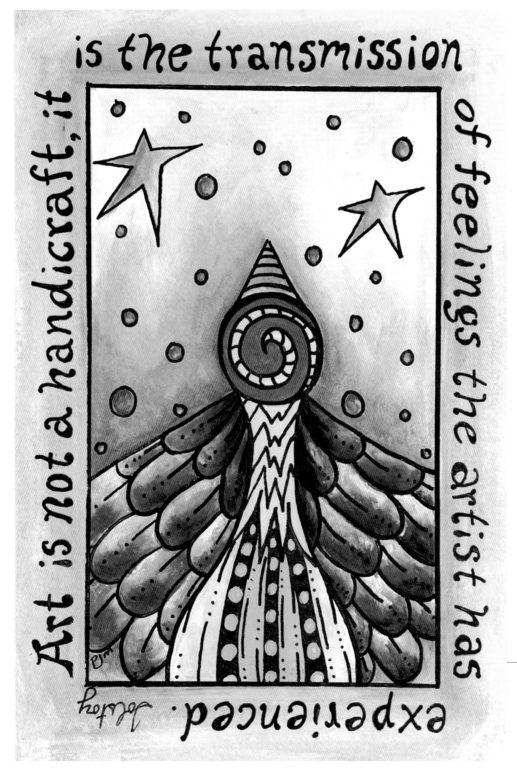

Feelings
PATRICIA J. MOSCA
5" × 7"
(13cm × 18cm)
illustration: acrylic,
watercolor paper

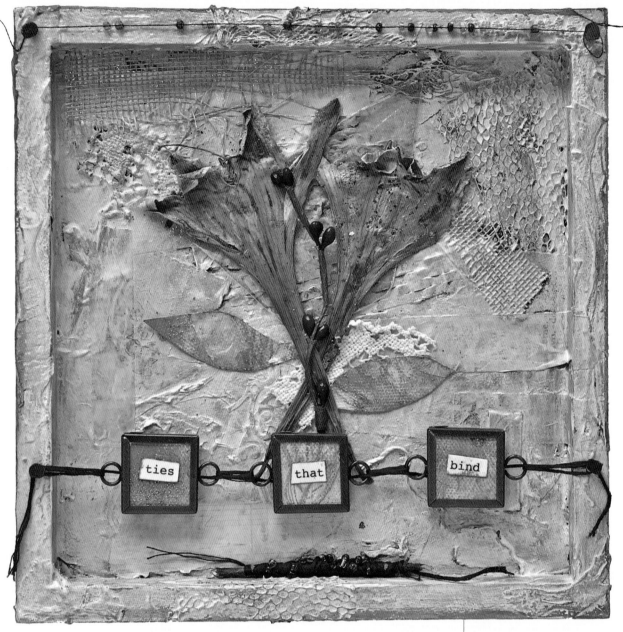

Red Thread | PATTI EDMON
8" × 8" (20cm × 20cm)
mixed-media collage

There's a thread that *binds all of us together;* pull on one end of the thread, the strain is felt all down the line.

ROSAMOND MARSHALL

Stay firmly in your path and dare; *be wild* two hours a day.

PAUL GAUGUIN

The Journey Is Easier With the Right Companions | LIZ KETTLE
11" × 14" (28cm × 36cm)
collage: paint, paper

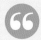

Grace must *find expression in life,* otherwise it is not grace.

— KARL BARTH

PHOTO BY T.R. SLOAN

Mixed Media | CAROL SLOAN
10" × 8" (25cm × 20cm)
painting: plaster gauze, joint
compound, canvas, carving, acrylic
paint, glazes, driftwood

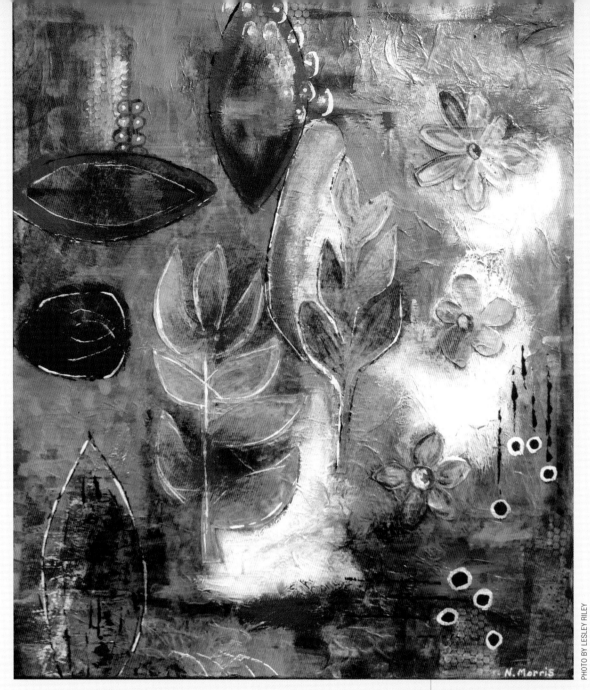

Kindness | NORINA MORRIS
20" × 24" (51cm × 61cm)
painting: acrylic, ink

"

Kindness in words creates confidence.
Kindness in thinking creates profoundness.
Kindness in *giving creates love.*

LAO TZU

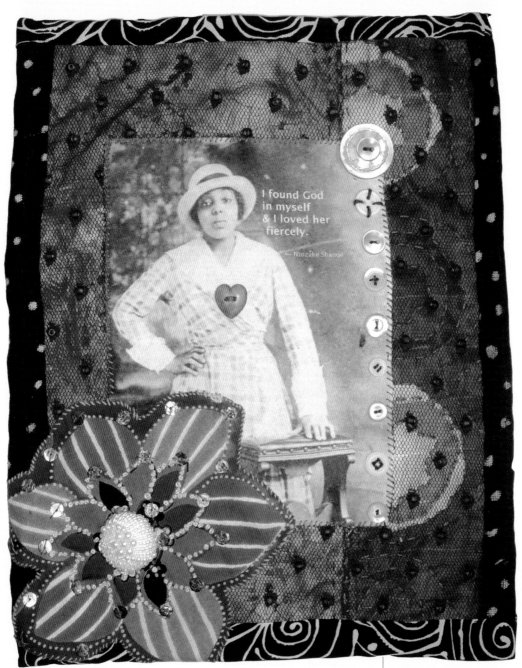

I Found God | SHIMODA
9¼" × 12" (23cm × 30cm)
quilt: fabric, appliqué,
hand stitched

> *i found God* in myself and i loved her,
> i loved her fiercely.

NTOZAKE SHANGE

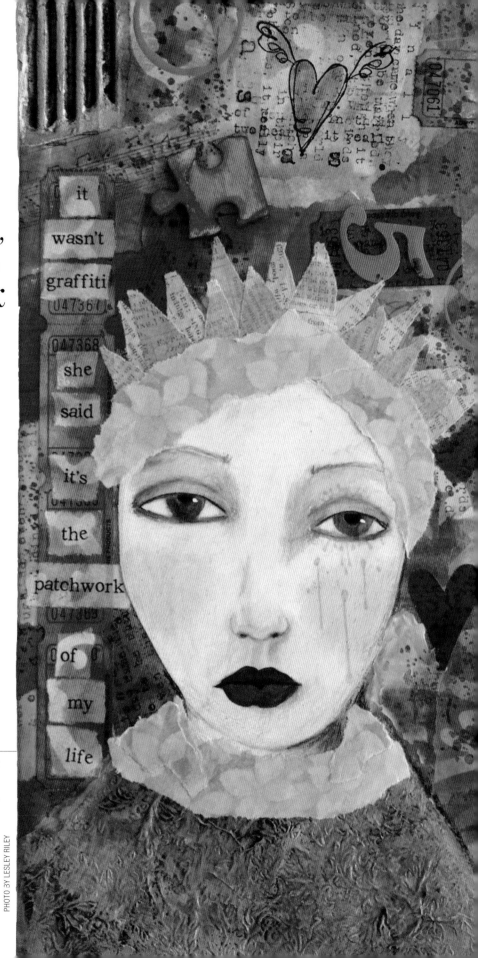

> ❝
> It wasn't graffiti,
> she said, it's the
> *patchwork
> of my life.*

— SUZE PERROTT

Untitled | SUZE PERROTT
6½" × 13" (17cm × 33cm)
mixed media: paint, pencil,
papers

PHOTO BY LESLEY RILEY

66 *Swimming upstream* and lovin' it.

{ BONNIE J. SMITH }

Swimming Upstream | BONNIE J. SMITH
30" × 40" (76cm × 102cm)
quilt: appliqué, cotton, wool, photo transfer,
fusing, machine quilting

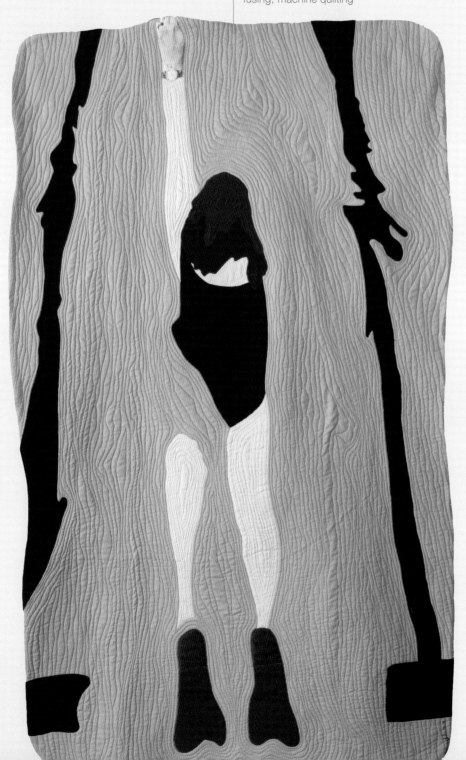

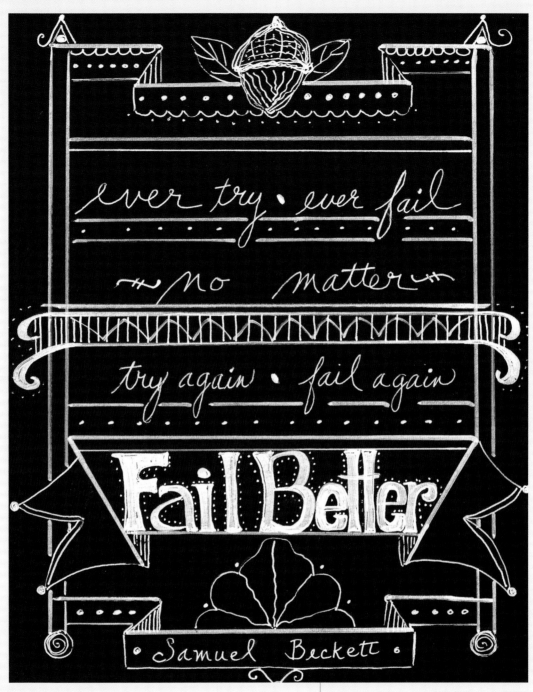

Fail Better | LORETTA BENEDETTO MARVEL
8½" × 11" (22cm × 28cm)
lettering: pen, chalk, cardstock

Ever try. Ever fail. No matter. Try again.
Fail again. *Fail better.*

{ SAMUEL BECKETT }

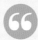

All the art of living lies in a fine mingling of *letting go and holding on.*

HAVELOCK ELLIS

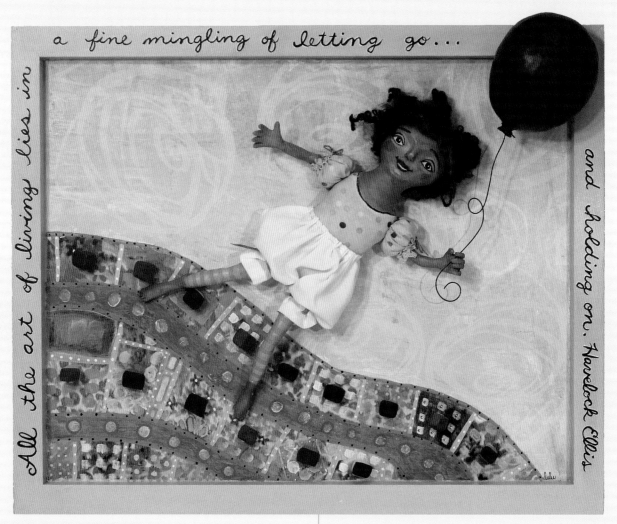

Letting Go & Holding On | LULU MOONWOOD MURAKAMI
20" × 16" (51cm × 41cm)
assemblage: sewn, sculpted, painted, collage, fabric,
paper clay, acrylic paint, wood, wire, paper

Moxie Metabolism | SUE BELLONE PERNA
24" × 24" (61cm × 61cm)
papier mâché: paper twisting, foil, metal findings

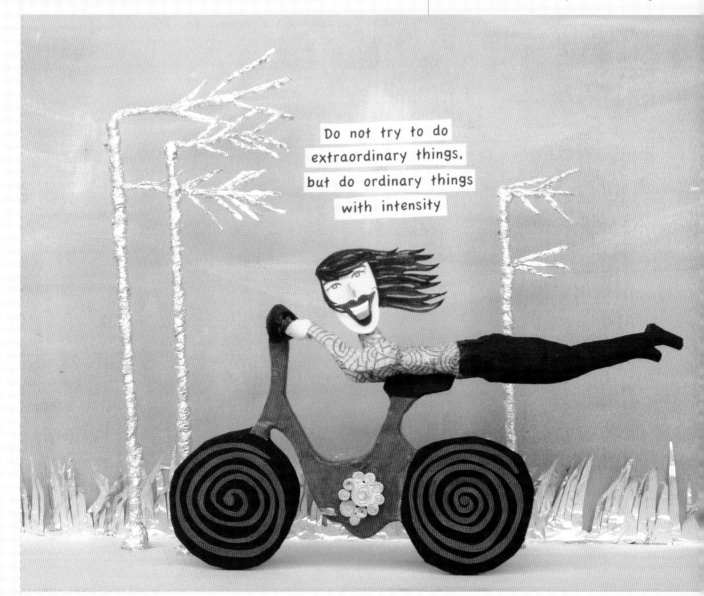

Do not try to do extraordinary things,
but do *ordinary things* with intensity.

EMILY CARR

Art offers sanctuary to everyone willing to *open their hearts* as well as their eyes.

NIKKI GIOVANNI

Sanctuary | KIRSTEN VARGA
8" × 10" (20cm × 25cm)
painting: crackle medium, acrylic paint,
transfers, alcohol inks, paint pen

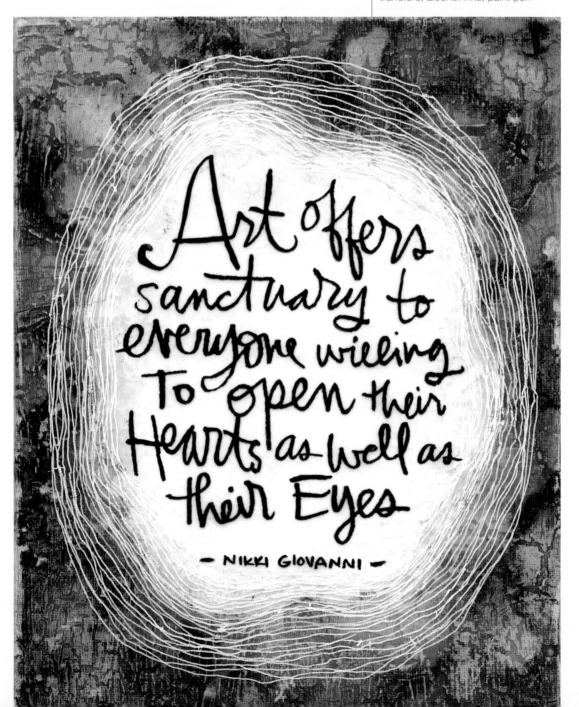

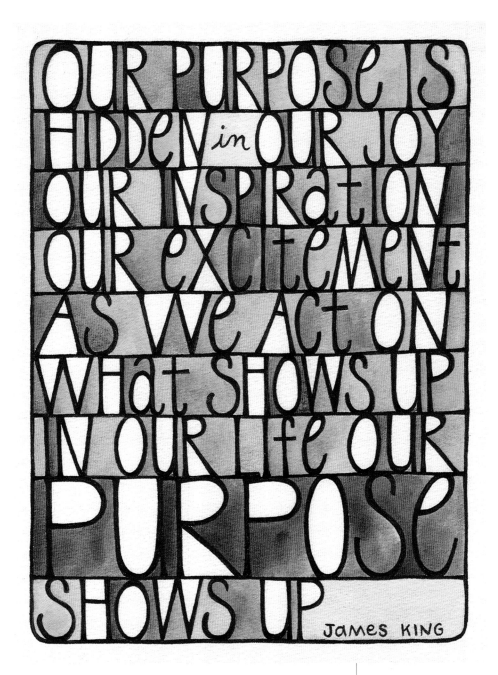

Purpose | PAT PITINGOLO
8" × 10" (20cm × 25cm)
illustration: watercolor

Our purpose is *hidden in our joy,* our inspiration, our excitement. As we act on what shows up in our life our purpose shows up.

JAMES KING

> ❝ **Toss in a stone and begin your own** *ripple of influence.*
>
> {JOY COOPER}

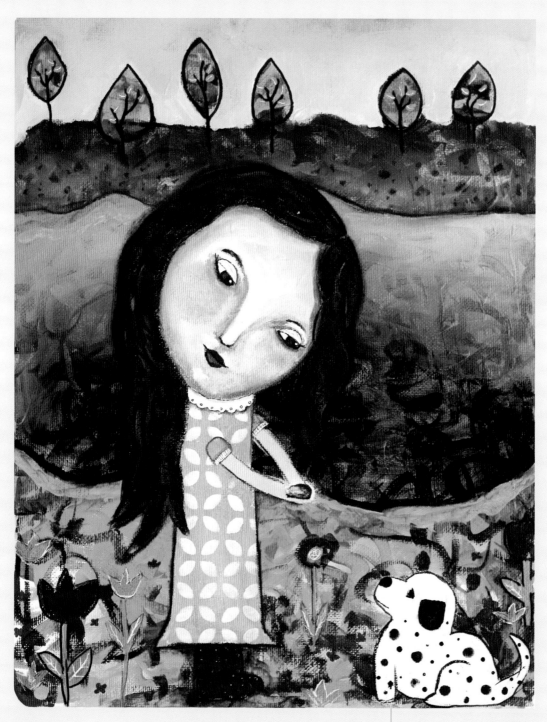

Believe | STEPHANIE ESTRIN
11" × 14" (28cm × 36cm)
acrylic painting

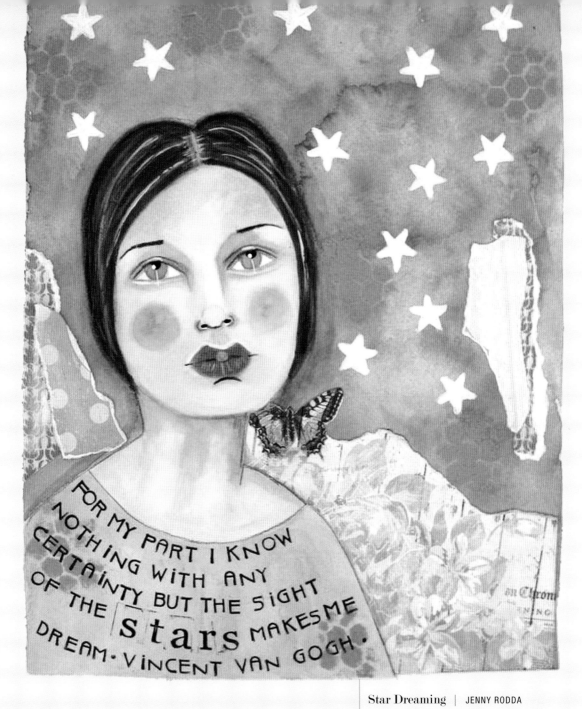

Star Dreaming | JENNY RODDA
8½" × 11" (22cm × 28cm)
watercolor: acrylic, ink, stamping, collage

> For my part I know nothing with any certainty but the sight of the stars *makes me dream.*

{ VINCENT VAN GOGH }

> ❝ *Go confidently* in the direction of your dreams. Act as though it were impossible to fail.

{ DOROTHEA BRANDT }

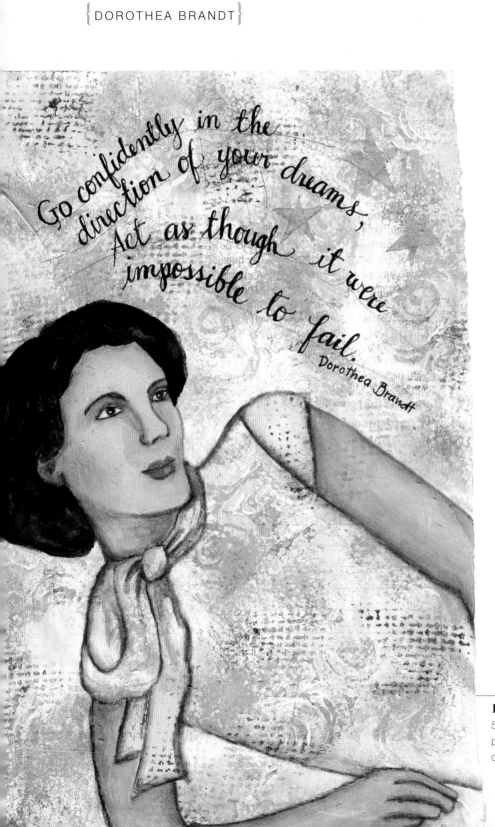

Dreams | PATRICIA PATERNO
5½" × 9" (14cm × 23cm)
painting: acrylic patina, gesso
on book paper

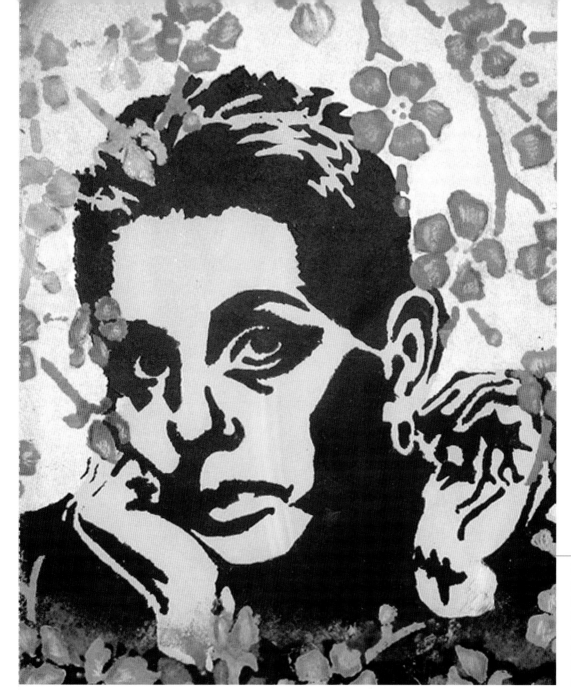

" Woman in harmony with her spirit is like a river flowing. *She goes where she will* without pretense and arrives at her destination prepared to be herself and only herself.

{ MAYA ANGELOU }

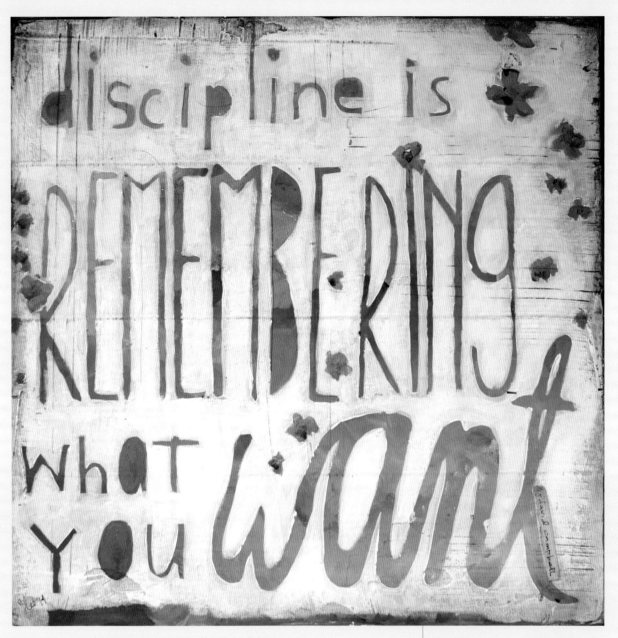

Discipline Is | STEPHANIE LEE
18" × 18" (46cm × 46cm)
mixed-media reverse painting: acrylic
over plaster, wood, acrylic, plaster

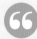

Discipline is *remembering what you want.*

DAVID CAMPBELL

> We tend not to choose the unknown and yet it is
> *the unknown* with all its disappointments
> and surprises that is the most enriching.

ANNE MORROW LINDBERGH

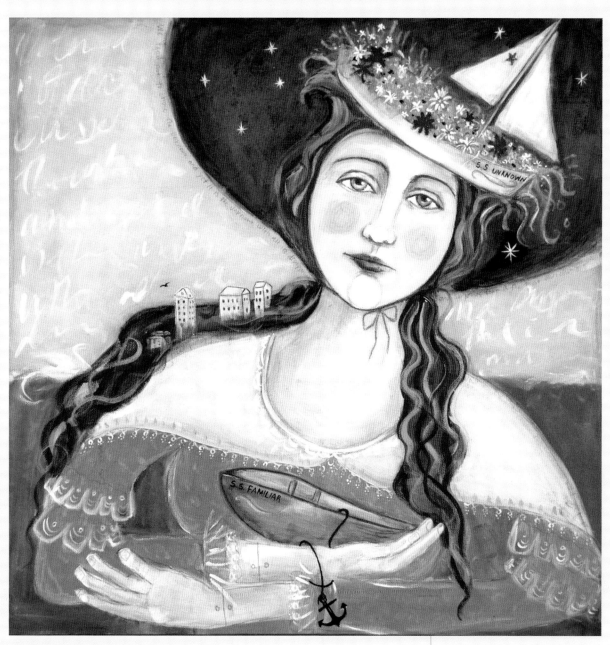

S.S. Unknown | TRICIA SCOTT
20" × 20" (51cm × 51cm)
painting: drawing, acrylic, graphite

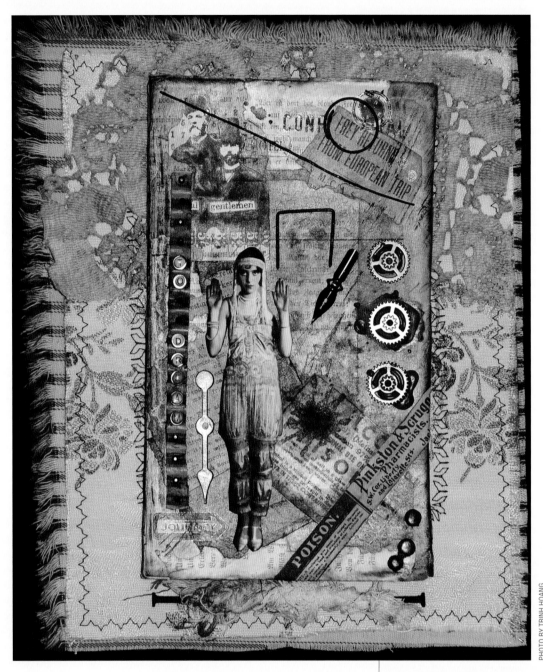

To Dream | MARLYNN LIKENS
8" × 10" (20cm × 25cm)
fabric collage: embellishments

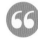

To dream of *the person you would like to be*
is to waste the person you are.

SHOLEM ASCH

If it scares you it might be a good thing to *try*.

SETH GODIN

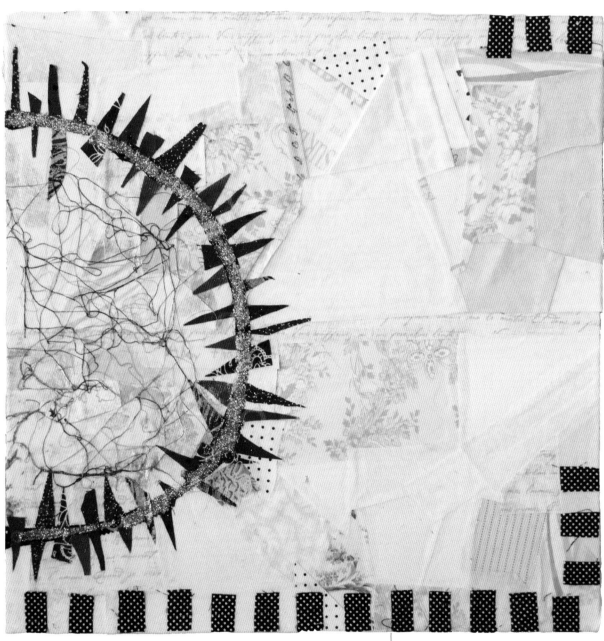

Ring of Fire | JENNIFER J. RODRIQUEZ
16" × 16" (41cm × 41cm)
textile collage: fabric, adhesive, paint, glitter

" Nothing is a mistake.
There's no win and no fail. There's only make.

SISTER CORITA KENT

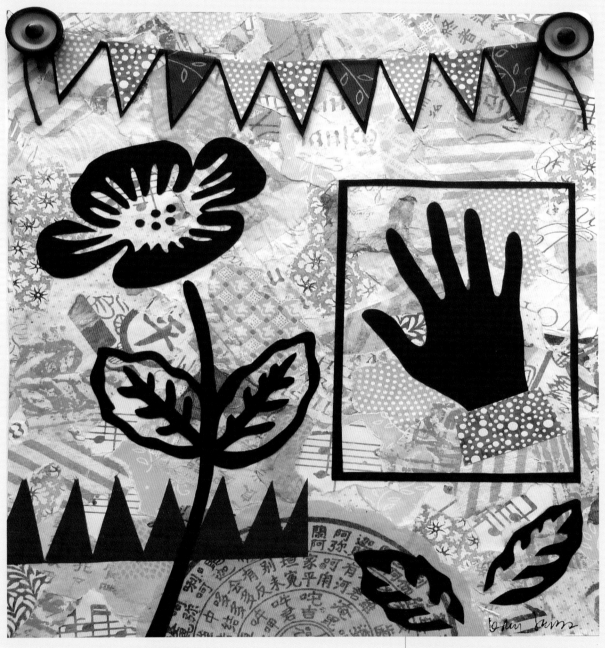

Poppy and Flags | LESLEY JACOBS
8" × 10" (20cm × 25cm)
collage: cut paper illustration, patterned
and black paper, thread, buttons

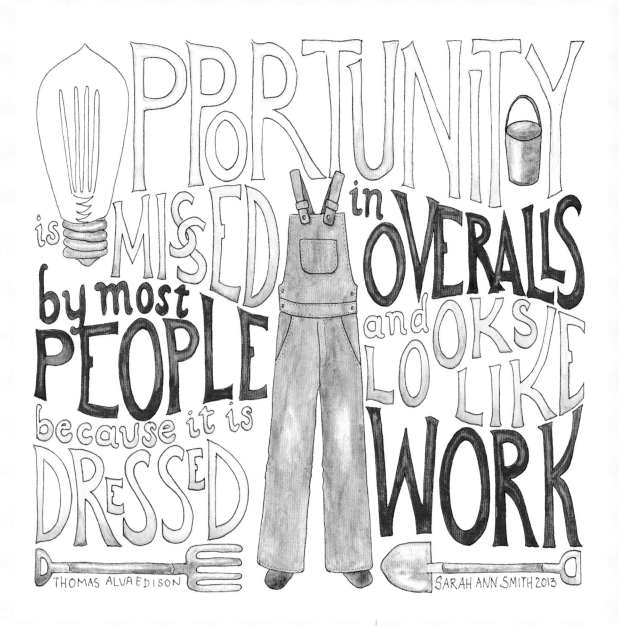

Opportunity in Overalls | SARAH ANN SMITH
12" × 9" (30cm × 23cm)
watercolor: paint, permanent ink pen

Opportunity is missed by most people because it is dressed in overalls and looks like work.

THOMAS ALVA EDISON

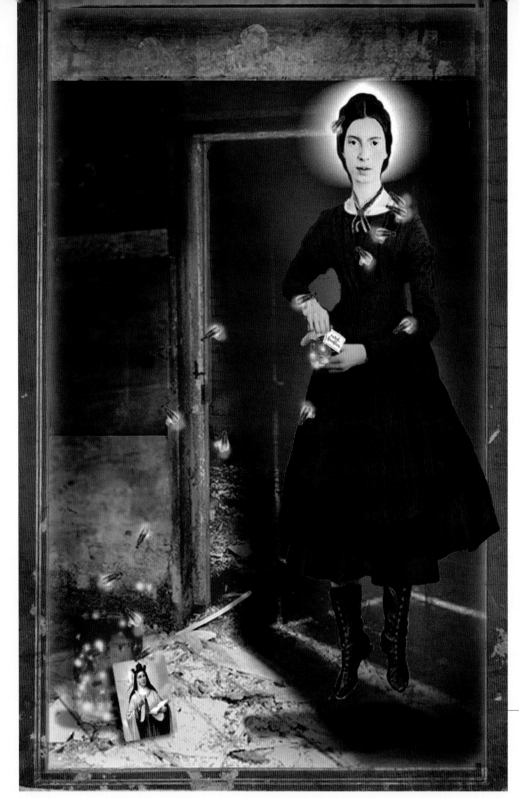

Saint Emily
SILVIA SOUZA
7" × 10"
(18cm × 25cm)
digital collage

66 The soul should always stand ajar, ready to welcome *ecstatic experience.*

{ EMILY DICKINSON }

 You never have to change anything you got up in the *middle of the night* to write.

{ SAUL BELLOW }

Saul's Truth | THERESA WELLS STIFEL
16" × 20" (41cm × 51cm)
collage: stitching, embroidery, acrylic paint, fabric, paper

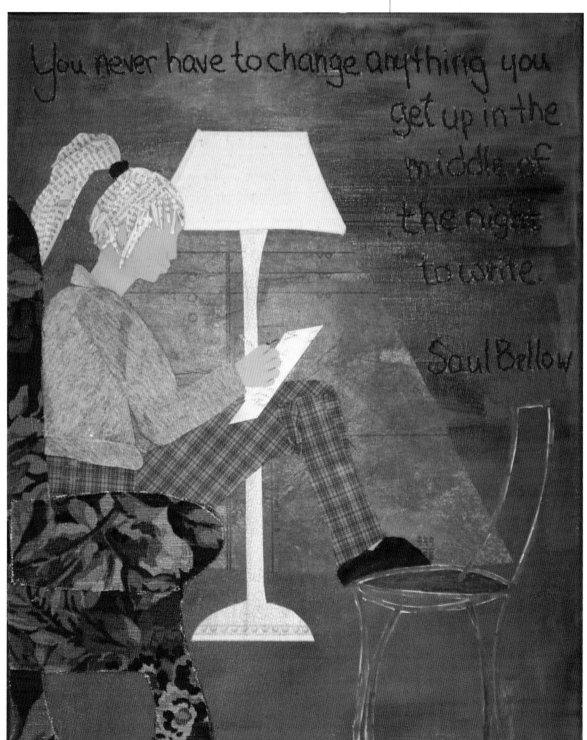

We have a tendency to obscure the *forest of simple joys* with the trees of problems.

{ CHRISTIANE COLLANGE }

Wrong Tree | LINDA H. MACDONALD
15" × 19" (38cm × 48cm)
quilt: appliqué, thread painting,
machine quilting

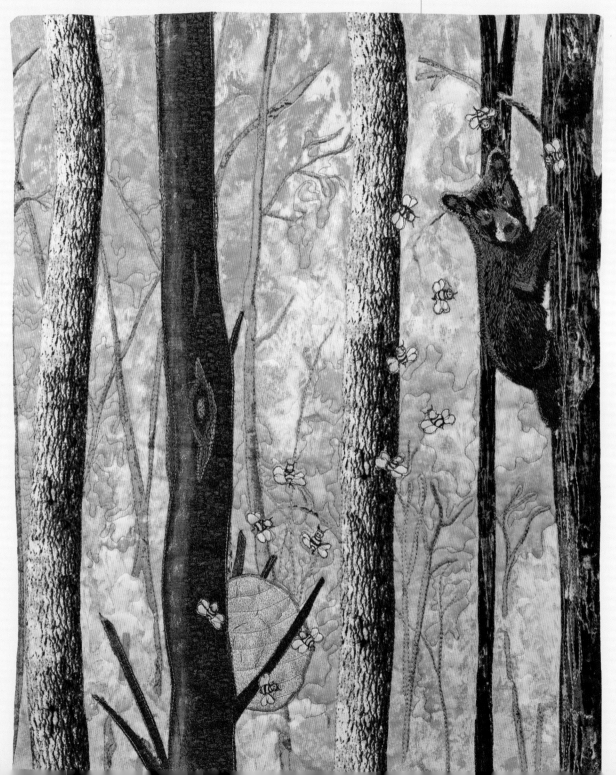

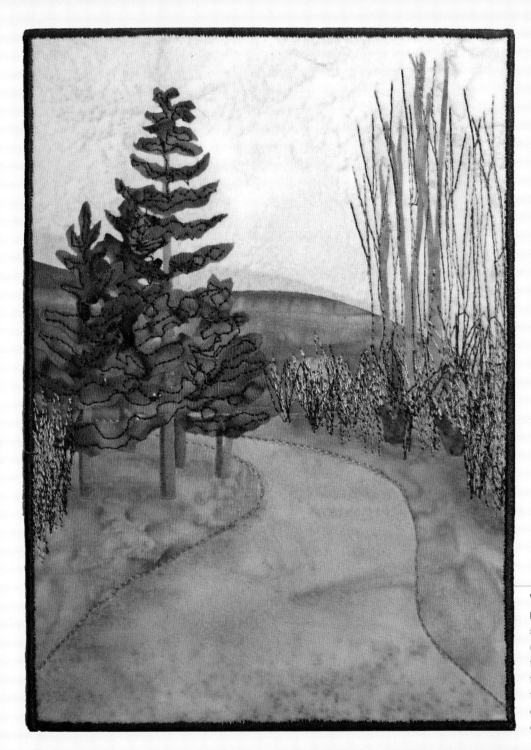

The Walker
DIANE BECKA
5" × 7"
(13cm × 18cm)
fabric collage:
fused appliqué,
free motion
embroidery,
colored pencil

" Above all, do not lose *your desire to walk.*
I have walked myself into the best thoughts.

{ SØREN KIERKEGAARD }

> **"** Each thing she learned became a part of herself to be used over and over in *new adventures.*
>
> { KATE SEREDY }

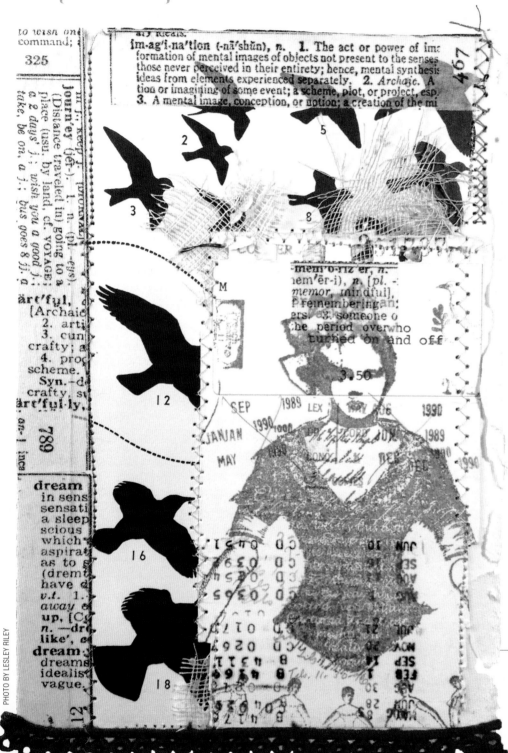

Learning Curve
ELLEN WILSON
5" × 7"
(13cm × 18cm)
collage: stamping,
stitching, paper,
embellishments

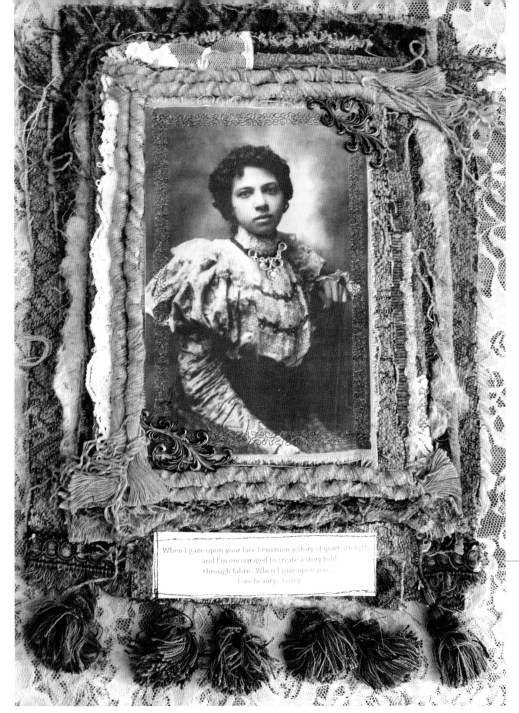

When I gaze upon your face
I envision a story of quiet strength and I'm encouraged to create a story through fabric. When I gaze upon you, I see beauty.

{ "LOVEY" LAVETTE JOHNSON-DEBROW }

Mary | KIM TEDROW
8" × 10" (20cm × 25cm)
collage: watercolor, acrylic
paint, paper, stencil

66 We are always the same age *inside.*

{ GERTRUDE STEIN }

I must be a mermaid. I have no fear of depths and a great fear of shallow living.

{ ANAÏS NIN }

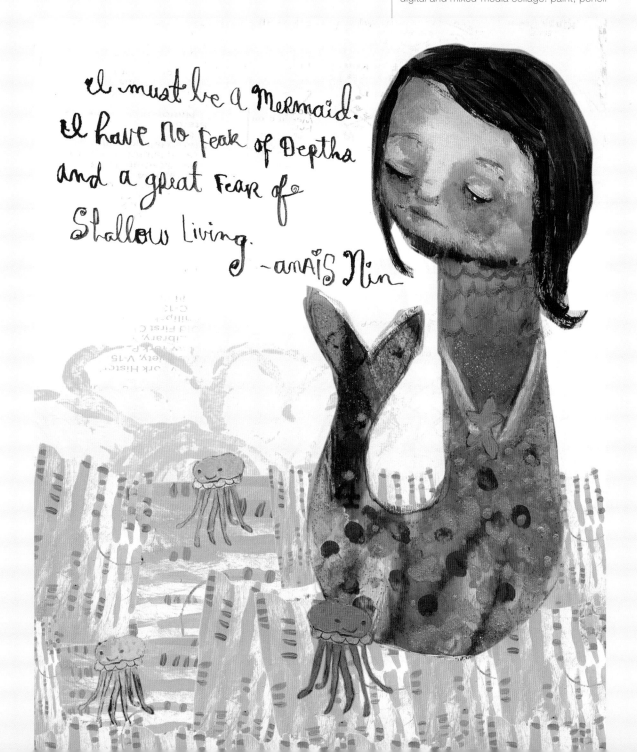

I must be a Mermaid. I have no fear of Depths and a great Fear of Shallow Living. —anais Nin

" I don't want to be a passenger *in my own life.*

{ DIANE ACKERMAN }

The Ride of Your Life | LIZ THORESEN
9" × 12" (23cm × 30cm)
painting: pastel, PanPastel, pastel pencils, collage

Curious | SANDY LUPTON
7" × 13" (18cm × 33cm)
collage: painting, deconstructed
screen print, drawing

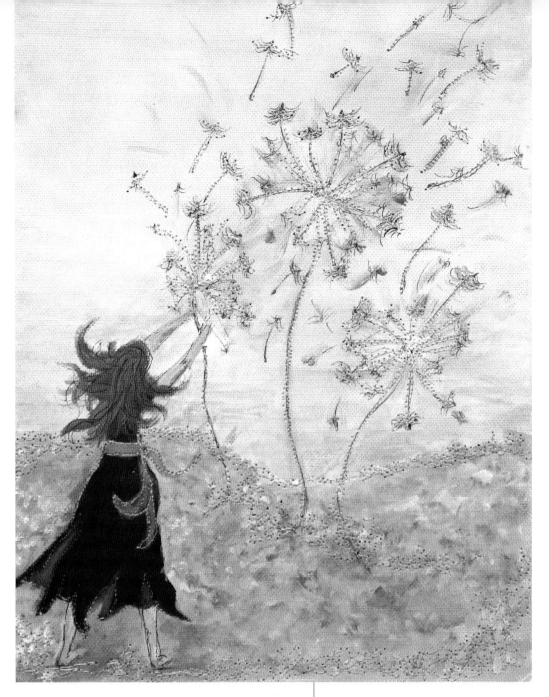

Change Is in the Wind | BARB INGERSOLL
10⅛" × 12⅞" (25cm × 33cm)
acrylic and watercolor painting on fabric:
machine stitched and embellished

Only one thing has to change for us to *know happiness* in our lives: where we focus our attention.

GREG ANDERSON

The muses *love* the morning.

BENJAMIN FRANKLIN

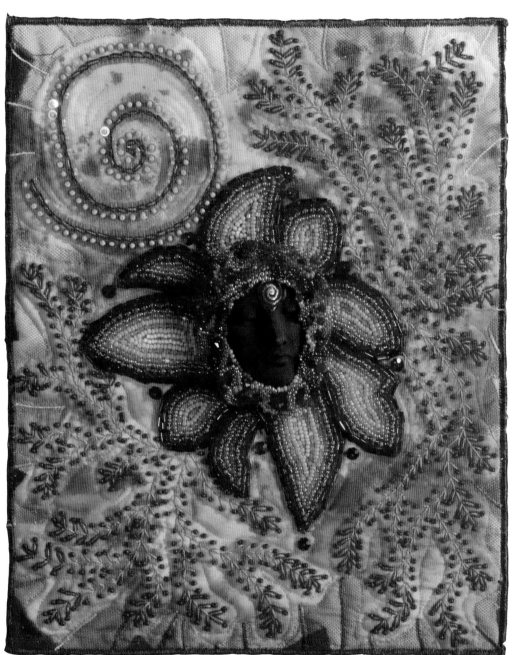

PHOTO BY G. ARMOUR VAN HORN

CERAMIC FACE BY DIANE BRIEGLEB

The Muses Love the Morning | LARKIN JEAN VAN HORN
8½" × 10½" (22cm × 27cm)
hand embroidery and beading: hand-painted cotton, tulle,
machine stitching, glass beads, Swarovski crystals

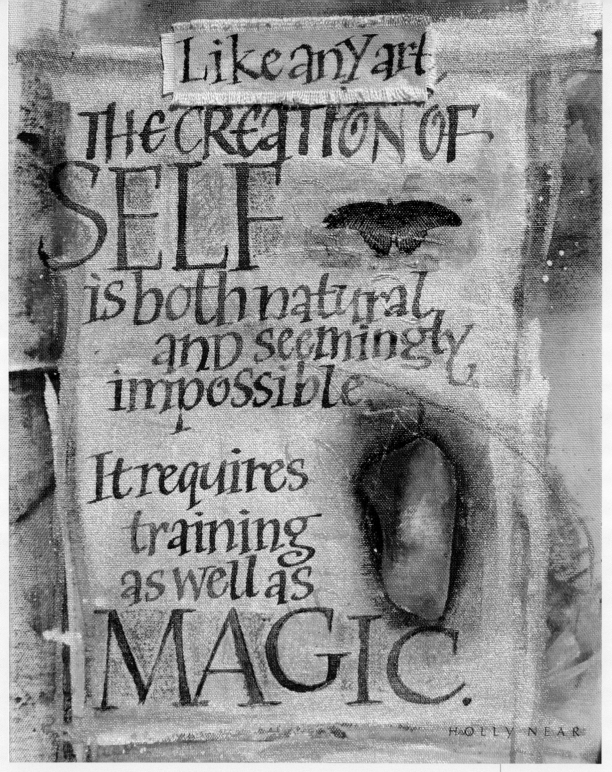

Like any art THE CREATION OF SELF is both natural and seemingly impossible. It requires training as well as MAGIC.

HOLLY NEAR

> " Like any art, the creation of self is both natural and seemingly impossible. It requires training as well as *magic.*

{ HOLLY NEAR }

Creation of Self
ROANN MATHIAS
11" × 14"
(28cm × 36cm)
collage: lettering,
transfer, canvas,
acrylic paint, matte
medium, oil pastels

> **No trumpets sound when the important decisions of our life are made.** *Destiny is made* known silently.

{ AGNES DE MILLE }

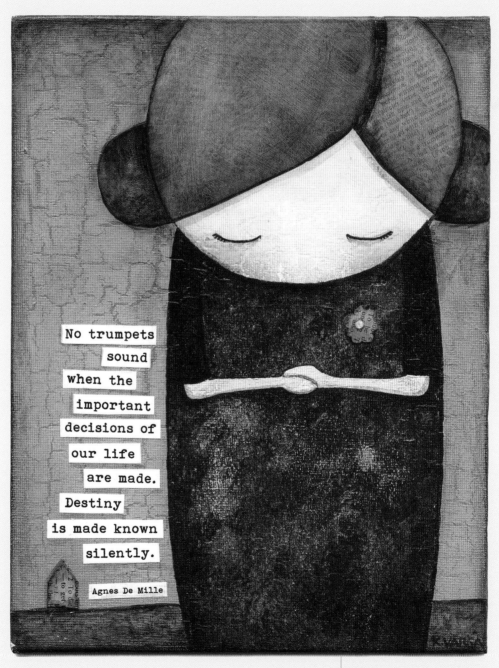

No trumpets
sound
when the
important
decisions of
our life
are made.
Destiny
is made known
silently.

Agnes De Mille

Destiny | KIRSTEN VARGA
7" × 9" (18cm × 23cm)
painting: collage, acrylic paint,
paper, crackle medium

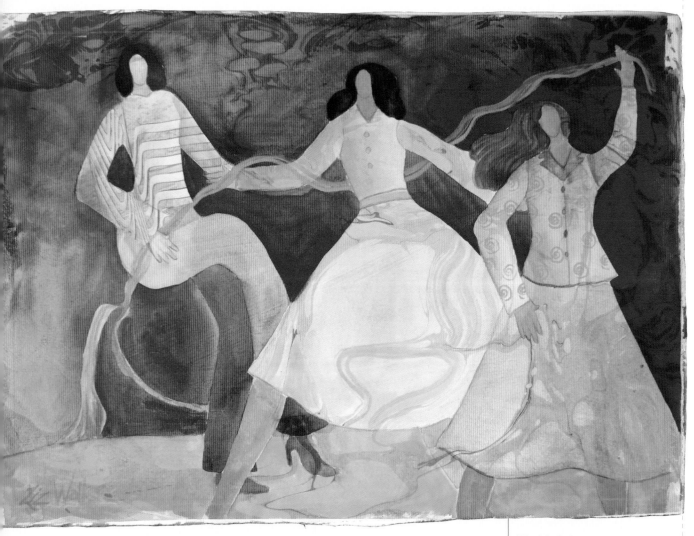

Untitled | LIZ WALKER
19" × 13" (48cm × 33cm)
acrylic marbling: acrylics

There are *shortcuts to happiness,*
and dancing is one of them.

VICKI BAUM

> # Some days there won't be a song in your heart. *Sing anyway.*

EMORY AUSTIN

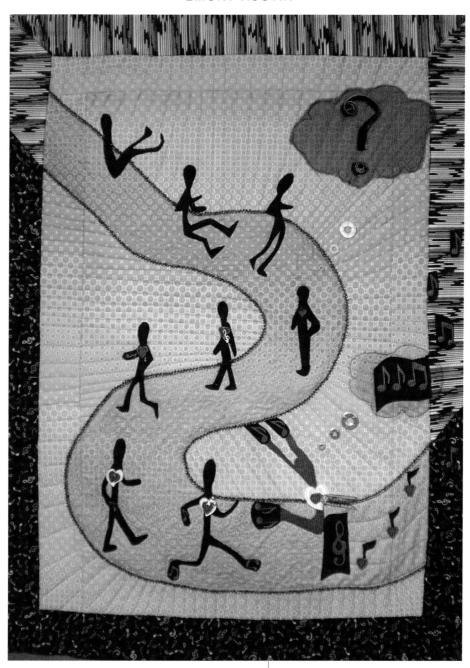

Persistence! | MEENA SCHALDENBRAND
22" × 30" (56cm × 76cm)
quilt: fabric, machine appliqué and
quilting, embellishments

> " The inner woman is the source of healing. The inner woman is the source of silence. The inner woman is the source of love. The inner woman is the source of belongingness with life. Embracing the inner man and woman is to *discover our inner roots* and wings.

{ SWAMI DHYAN GITEN }

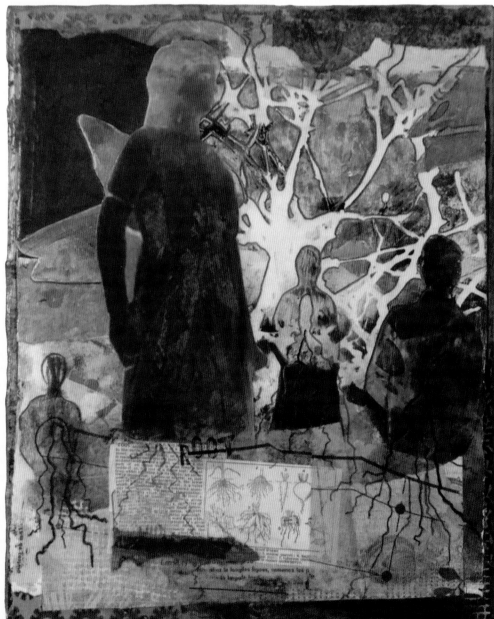

The Roots of Being
SARA WHITE
11" × 14"
(28cm × 36cm)
collage:
printmaking,
paper, acrylic
paint, graphite,
acrylic medium,
polymer varnish

134

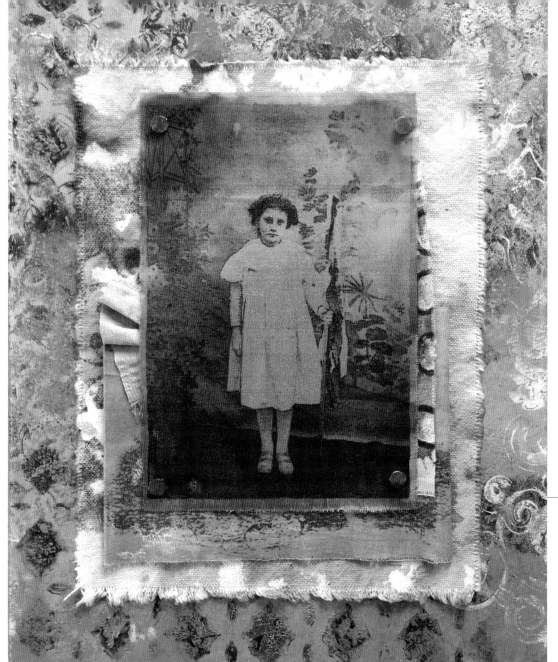

66 People become really quite remarkable when they start thinking that they can do things. When they believe in themselves they have the first *secret of success.*

{ NORMAN VINCENT PEALE }

LESLEY'S FAVORITE
quote resources

WEBSITES

ThinkExist.com
BrainyQuote.com
PaintersKeys.com
GoodReads.com (Explore >
Quotes)

COPYRIGHT-FREE
IMAGE SOURCES

e-vint.com
nos.twnsnd.co (yes, dot co)
vintageprintable.com
loc.gov/pictures
digitalgallery.nypl.org
thegraphicsfairy.com
unprofound.com

Always be aware of and abide
by any copyright restrictions on
images you use in your artwork
unless your use will always be
strictly personal, for your eyes only.

YOUR TURN!
GET CREATIVE WITH
QUOTES

Choose a quote from the book or
one of the above websites.

• How does this quote make
 you feel? Spend some time
 mulling this over.

• What colors does it bring
 to mind?

• What symbols, objects,
 images or photos from your
 past or present could you use
 to show and describe your
 feelings?

• Gather some papers, glue,
 paint, markers or colored
 pencils. Using magazine
 images or your own items,
 create a collage that expresses
 the feeling and inspiration you
 get from the quote.

• Consider keeping a personal
 journal of quotes that you
 find inspiring and motivating.
 Make it your private place to
 go wild with your thoughts,
 color, image and whatever
 moves you. I can tell you from
 experience that the more
 intimate and familiar you get
 with quotes, the more they
 can change your life . . . for the
 better. And you can quote me
 on that!

Visit CreateMixedMedia.com/inspirational-quotes-illustrated for downloadable wallpaper.

contributors

Christine Adams
p44 Breathtaking
StoriesinFabric.com

Joyce Adomaitis/JaDivaJoy
p68 Scattered Hearts
JaDivaJoy.com

Cheryl Alt
p59 Do It Now!
Photo by Britni Wilson

Catherine Anderson
p13 Inspiration Arriving
CatherineAndersonStudio.com

Seth Apter
p9 Quite Still
TheAlteredPage.blogspot.com

Gina Rossi Armfield
p12 Untitled
NoExcusesArt.com

Doris Arndt
p79 Other Than Human

Jan Avellana
p35 I Would Still Plant My Apple Tree
JanAvellana.com

Linda C. Bannan
p14 Call It Joy
Photo by Mike Bannan

Serena Barton
p7 The Smallest Thing
SerenaBarton.com

Diane Becka
p121 The Walker
DianeBecka.com

Marcia Beckett
p19 We Are So Many Selves
MarciaBeckett.blogspot.com

Jill K. Berry
p36 Make It New
JillBerryDesign.com

Fajari Bertels-Thenu
p26 Sunrise
Fajari.com

Deborah Boschert
p22 Wider Possibilities
DeborahsStudio.com

Darlene Campbell
p23 Mysteries of the Imagination
p58 Nothing Standard Here
Darlene-Freeniebelle.blogspot.com

Chris Capista
p50 The Dreamer
capista52@yahoo.com

Joyce L. Carrier
p20 Autumn Paths
CarrierClothworks.com

Pam Carriker
p38 My Imagination Runs Riot
p34 Youth Remembered
PamCarriker.com

Michelle Casey
p82 In My Secret Garden
Photo by Peter Farris-Manning
CollageYourWorld.com

Lisa Chin
p43 Grab Joy
SomethingCleverAboutNothing.
blogspot.com

Carol Clarkson
p51 Indian Chief
Photo by Hunter Clarkson
CarolClarksonPottery.com

Dawn Collins
p28 Meditating Girl
p29 Peace Art
ZetasAtticArt.blogspot.com

Sarah Cooper
p45 Untitled (Bernhardt)
p40 Untitled (Warhol)

Chris Cozen
p57 More Is Hidden
ChrisCozenArtist.typepad.com

NM Creatrix
p8 Place of Power
CreativityContinium.com

Adeola Davies-Aiyeloja
p39 Green Mother Earth
p15 Organic Red—Steps of Vision
Facebook.com/AdeolaStudio

Sign up for the free newsletter at **CreateMixedMedia.com**.

Marlynn Likens
p114 To Dream
Photo by Trinh Hoang
HoneysuckleBreeze.blogspot.com

Gina Louthian-Stanley
p77 Whispers of the Moon
GinaLouthian-Stanley.blogspot.com

Sandy Lupton
p127 Curious
p81 Luna
shooting-star-gallery.com

Linda H. MacDonald
p120 Wrong Tree
macsplace.net/quilt.html

Judith Mangiameli
p83 Muzzle

Cheryl Bakke Martin
p18 You Are What You Are When
Nobody Is Looking
inspirations-studio.com

Catherine Martin
p84 Oasis of Refreshment

Theresa Martin
p80 Here Comes the Sun
theresamartin.com

Roann Mathias
p130 Creation of Self
Roanndesigns.com

Loretta Benedetto Marvel
p103 Fail Better
p87 May Sarton
artjournaler.typepad.com/
pomegranatesandpaper

Misty Mawn
p89 Feed the Soul
MistyMawn.typepad.com

Corinne Meharg
p90 Lake Whispers
Photo by Lesley Riley
Quiltodontist.wordpress.com

Stacey Merrill
p66 Color the Sky
p10 Soaring
artsnark.blogspot.com

Bridgette Guerzon Mills
p56 Fragments
GuerzonMills.com

Linda Teddlie Minton
p93 Ring the Bells
fiberreflections.blogspot.com

Susie Monday
p94 When You Look at Art
SusieMonday.com

Patti Monroe-Mohrenweiser
p69 Invincible Summer
p25 Spiritual Beings
BeyondLetters.com

Pearl Red Moon
p62 A Thread That Runs Through
pearlredmoon.com

Norina Morris
p99 Kindness
Photo by Lesley Riley

Patricia J. Mosca
p95 Feelings
pjmosca.com

Lulu Moonwood Murakami
p104 Letting Go & Holding On
lulumoonart.com

Karen O'Brien
p85 The Color of Spring
KarenOBrien.blogspot.com

Sandy Ohlson
p73 Let Them Eat
Photo by Anne Lorys
SandyOhlsonFloralDesign.com

Patricia Paterno
p110 Dreams
patsypat.blogspot.com

Judy Coates Perez
p52 We Are Cups
JudyCoatesPerez.com

Sue Bellone Perna
p105 Moxie Metabolism

Suze Perrott
p101 Untitled
Photo by Lesley Riley
PinkCrayonStudio.blogspot.com

Pat Pitingolo
p107 Purpose
PatPitingolo.blogspot.com

Lesley Riley
p135 Secret of Success
p5 That Self
LesleyRiley.com

Jenny Rodda
p109 Star Dreaming

Jennifer J. Rodriguez
p115 Ring of Fire
AllThingsBelle.blogspot.com

Sandra Ahlgren Sapienza
p111 Judith

Meena Schaldenbrand
p133 Persistence!
MeenaSchaldenbrand.blogspot.com

Tricia Scott
p113 S.S. Unknown
tricia-scott.com

Mary Beth Shaw
p91 In This Moment
MBShaw.com

Shimoda
p100 I Found God
Shimoda-Accessories.com

Carol Sloan
p98 Mixed Media
Photo by T.R. Sloan
CarolBSloan.blogspot.com

Bonnie J. Smith
p102 Swimming Upstream
Photo by Luke Mulks
BonnieJoFiberarts.com

Sarah Ann Smith
p117 Opportunity in Overalls
SarahAnnSmith.com

Silvia Souza
p118 Saint Emily

Joanie Springer
p75 Emily Hurries Home in Time for
Tea
ArtFortheSoulofIt.com

Cheryl Stevenson
p92 Grace
CherylStevenson.weebly.com

Rachel Stewart
p48 State of Mind
Photo by Darren Lykes Photography
BlueFinchJewelry.blogspot.com

Theresa Wells Stifel
p119 Saul's Truth
StifelandCapra.com

Vicki Szamborski
p72 The Rose
VickiInYourHead.wordpress.com

Kim Tedrow
p124 Mary
KimTedrow.blogspot.com

Liz Thoresen
p126 The Ride of Your Life
LizThoresen.com

TiCo
p54 Subtle Blatancy
Photo by Lisa Akers, Crawford
Photography, LLC
KnitFunctionalFamily.blogspot.com

Tamara Tolkin
p30 Bury Doubt Under Wonder

Michelle Tompkins
p88 Beginning of a Beginning
Photo by Russ Pace
VindicatedStudios.com

Larkin Jean Van Horn
p129 The Muses Love the Morning
Photo by G. Armour Van Horn
LarkinArt.com

Kirsten Varga
p131 Destiny
p106 Sanctuary
SmilingEyeStudio.blogspot.com

Liz Walker
p132 Untitled
LizWalkerArt.com

Kim Ward
p78 Free Your Heart
KimMarieWard.blogspot.com

Sara White
p134 The Roots of Being
Photo by Lesley Riley

Ellen Wilson
p122 Learning Curve
Photo by Lesley Riley
EllasEdge.blogspot.com

Nanette S. Zeller
p21Courage
NanetteSewz.com

index

ABOUT THE AUTHOR

Lesley Riley wears many hats. She is an internationally known artist, art quilter, teacher, writer and Artist Success coach and mentor who turned her initial passion for photos, color and the written word into a dream occupassion.

Her art and articles have appeared in too many places to keep count. As former contributing editor of *Cloth Paper Scissors* magazine, Lesley developed a passion for showcasing new talent in mixed-media art, now evidenced in this book you hold in your hands. Her first book, *Quilted Memories*, brought new ideas and techniques to quilting and preserving memories. A second, *Fabric Memory Books*, combined fabric and innovative ideas with the art of bookmaking. Two more books, *Fabulous Fabric Art With Lutradur* and *Create With Transfer Artist Paper,* introduced versatile new materials to the mixed-media art world and led to a fifth book in 2014, *Creative Image Transfer.*

In an ongoing effort to find the best ways for quilters and mixed-media artists to get permanent photos on fabric, paper and more Lesley introduced Transfer Artist Paper™, named the Craft & Hobby Association 2011 Most Innovative new product, the state-of-the-art technology for iron-on transfers.

Lesley is the former host of BlogTalkRadio's Art & Soul show, recording over seventy-five podcasts on art and the creative process through in-depth interviews with contemporary artists. Her passion and desire to help every artist reach their creative dreams and potential has led to a growing specialty as an Artist Success coach and mentor where she draws from her own experience, insight and a knack for seeing the potential in everyone to provide guidance and solutions for artists of all levels.

Lesley creates her magic on an idyllic horse farm in Frederick, MD, where she lives with her high school sweetheart husband and two of her six children. You'll find her in her studio from sunup to sundown unless, of course, any of her seven granddaughters come to visit.

Stay connected and inspired! Sign up for Lesley's free biweekly dose of inspiration and motivation at LesleyRiley.com.

ACKNOWLEDGMENTS

It is clear that this book would not exist without the words, wisdom and talent of many people. I am but a gatherer who strives to inspire and motivate others to be their best self.

First and foremost, I want to thank Tonia Jenny, my acquisition editor at North Light, for understanding the value and intention of this book and all the work she did to get it into the hands of so many more people. Amy Jones, my book editor, took what I gathered and worked her magic so the art and wisdom within shines even brighter.

Thanks also go to the entire team that it takes to move a book from a passionate idea to the hands of its readers. I notice and you rock.

DEDICATION

To all the wise men and women who wrote or said the words that inspired me, the book and the art within.

To all the artists who answered my call for art. Whether your creation made it into the book or not, I offer you my gratitude for your contribution. This book would not exist without you.

fw
a content + ecommerce company

Other fine North Light Books are avail-
able from your favorite bookstore, art
supply store or online supplier. Visit our
website at fwmedia.com.

18 17 16 15 14 5 4 3 2 1

DISTRIBUTED IN CANADA BY
FRASER DIRECT
100 Armstrong Avenue
Georgetown, ON, Canada L7G 5S4
Tel: (905) 877-4411

DISTRIBUTED IN THE U.K. AND EUROPE
BY F&W MEDIA INTERNATIONAL, LTD
Brunel House, Forde Close, Newton Abbot, TQ12 4PU, UK
Tel: (+44) 1626 323200, Fax: (+44) 1626 323319
Email: enquiries@fwmedia.com

DISTRIBUTED IN AUSTRALIA BY CAPRICORN LINK
P.O. Box 704, S. Windsor NSW, 2756 Australia
Tel: (02) 4560-1600; Fax: (02) 4577 5288
Email: books@capricornlink.com.au

ISBN 13: 978-1-4403-3840-3

EDITED BY **Amy Jones**

DESIGNED BY **Hannah Bailey**

PRODUCTION COORDINATED BY **Jennifer Bass**

Metric Conversion Chart

TO CONVERT	TO	MULTIPLY BY
INCHES	CENTIMETERS	2.54
CENTIMETERS	INCHES	0.4
FEET	CENTIMETERS	30.5
CENTIMETERS	FEET	0.03
YARDS	METERS	0.9
METERS	YARDS	1.1

Ideas. Instruction. Inspiration.

Receive **FREE** downloadable bonus materials when you sign up for our free newsletter at CreateMixedMedia.com.

Find the latest issues of *Cloth Paper Scissors* on newsstands, or visit shop.clothpaperscissors.com.

These and other fine North Light products are available at your favorite art & craft retailer, bookstore or online supplier. Visit our websites at createmixedmedia.com and artistsnetwork.tv.

Follow CreateMixedMedia.com for the latest news, free wallpapers, free demos and chances to win **FREE BOOKS!**

Get your art in print!

Visit **CreateMixedMedia.com** for up-to-date information on *Incite* and other North Light competitions.